IMAGES
of Rail

TACOMA RAIL

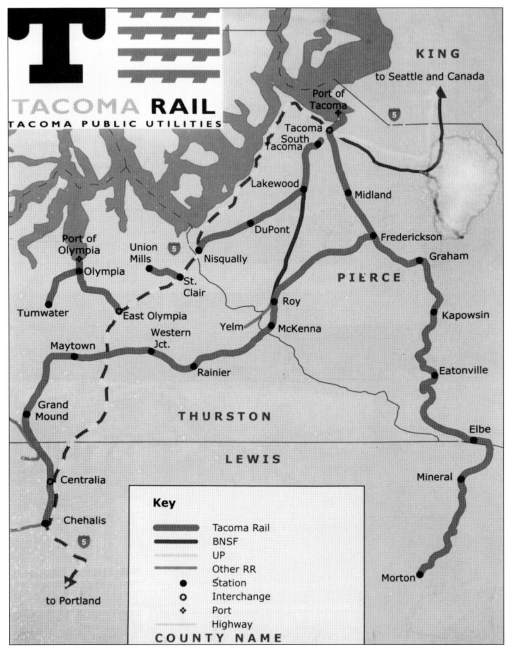

TACOMA RAIL MAP. This map shows the expanded Tacoma Rail that reaches out past Tacoma into Pierce and Thurston Counties. (Courtesy of Mike Klass of Tacoma Rail.)

ON THE COVER: Here, the No. 903 is pulling freight cars in the Tide Flats on the Tacoma Municipal Belt Line. This picture appears in the January 14, 1948, *Tacoma News Tribune*. Nos. 903 and 904, which are identical, were purchased from the War Assets Administration for $41,000 for both of them. (Courtesy of Tacoma Public Library.)

IMAGES
of Rail

TACOMA RAIL

David J. Cantlin

ARCADIA
PUBLISHING

Copyright © 2013 by David J. Cantlin
ISBN 978-1-4671-3006-6

Published by Arcadia Publishing
Charleston, South Carolina

Printed in the United States of America

Library of Congress Control Number: 2012956026

For all general information, please contact Arcadia Publishing:
Telephone 843-853-2070
Fax 843-853-0044
E-mail sales@arcadiapublishing.com
For customer service and orders:
Toll-Free 1-888-313-2665

Visit us on the Internet at www.arcadiapublishing.com

To my family, who put up with me, and to the hardworking employees of Tacoma Rail, past and present

Contents

Acknowledgments		6
Introduction		7
1.	Seedbed for Economic Development	9
2.	Trolley Town	25
3.	The Making of the Belt Line	47
4.	Expansion	97
5.	Passenger Excursions	109

ACKNOWLEDGMENTS

I discovered early on with this project that no book is the result of one author. This is even more so the case if one is writing a historical pictorial book covering events before the author's own advent on this planet. This book would not have been possible without help from the following individuals and organizations: Arcadia Publishing, for giving me the opportunity to document the positive contribution Tacoma Rail has made to its community; Dale King, the current superintendent of Tacoma Rail, who, on more than one occasion, allowed me to access staff and files; Alan Hardy; Joe Furtney of Tacoma Rail; Mike Klass of Tacoma Rail; Walt Ainsworth, who is the steward of the late Warren Wing's photograph collection; Martin E. Hansen, who has awesome photographs of the Belt Line's steam switcher from the Al Farrow Collection; Paul Curtiss, who came forward with tons of Tacoma Trolley information; Tim Johnson, who shot maps for me and was a constant source of encouragement; Jim Frederickson, who allowed me to look through his collection; Peter Replinger, Tacoma Public Library Collection, and the more than helpful library staff; the Washington State History Museum; Gary Tarbox, with the Northwest Railroad Archives; University of Washington Photographs Collection; Pacific Northwest Chapter of the National Railway Historical Society; Tacoma Public Utilities Archives; Kelley Bennett, for proofreading the text; and to my many Facebook friends, who, like cheerleaders, encouraged me to keep on.

The author also heavily leaned on John S. Ott's book *The Story of the Tacoma Municipal Belt Line Railway: Proudly serving Tacoma since 1914*.

Introduction

It is late at night, and a low, mournful horn sounds in the distance but then quiets. A minute or two later, a steady rumble is heard with growing intensity. A bright light appears, and as the approaching train rumbles by, the horn sounds again, only much louder this time. Again, Tacoma Rail's battle with the 3.3-percent grade of the Tacoma Gulch is on. Two thundering locomotives, with a headlight piercing the night, rumble by in notch 8. As the train crests the grade and the locomotives notch their throttles down, the contest has been won over the gulch. Tacoma Rail, along with other railroad predecessors, has repeated this almost daily for over 100 years.

Tacoma Rail has existed in one form or the other since 1917, when it was a trolley line used to move factory workers to and from the Tide Flats. In October 1917, freight operations started up with the line providing limited switching service in conjunction with the national railroads. Early on, the line was called the Tacoma Municipal Street Railway.

As industry developed in the Tide Flats, the Municipal Railway's role providing switching service expanded. The Muni Line was turning into a conflicted operation. On one hand, it was a trolley moving workers to and from work and losing money. On the other hand, the switching operation was growing and showing earning potential. The two different operations were not compatible with each other, and the track to support both types of operations did not exist. At first, switching operations were performed at night when the trolleys were not running. This was only a Band-Aid on the issue.

Ernest Dolge was the patron saint for the Municipal Railway. He saw a real future for a terminal railroad in the Tide Flats to serve the growing industry. He also believed that such a railroad should be owned and controlled by the city. Being a mill owner in the Tide Flats gave him a good perspective of the needs. The long-term result of his labor was the Tacoma Municipal Belt Line (TMBL); it was a terminal railroad whose purpose was not necessarily to earn a profit, but to attract and serve industry to the Tacoma Tide Flats.

Freight service continued to grow and show promise while passenger service continued to be a drain on the Belt Line's coffers. This led to the replacement of trolleys with buses and the eventual turning over of this operation to Tacoma Transit (present-day Pierce Transit). The Belt Line was now in a better position to focus on its freight operation.

By 1942, the Belt Line was serving 27 industries on 13 miles of track. This success brought congestion and complaints from shippers. The national railroads that served Tacoma (Union Pacific, Northern Pacific, Great Northern, and the Milwaukee) were asked to study the Belt Line and make suggestions to ease the congestion and streamline the operation. Their recommendations included extending sidings and also building a central classification yard that the national roads could bring their cars to for the Belt Line to distribute throughout the Tide Flats. The yard was built parallel to the Milwaukee's car shops on Milwaukee Way.

The war years brought prosperity to Tacoma and its port, which benefitted the Belt Line. Logs and lumber were still the kings of freight traffic, but they were supported by a good mixture of

chemicals, grains, and finished products that rounded out Tacoma Belt Line's bottom line. During this time, there were offers and counter offers to sell the Belt Line to either the national roads or to the port. In the end, the Belt Line survived these attempts and was made part of Tacoma Public Utilities.

Through expansion of the port, Tacoma Belt Line was able to build a new classification yard and office facility. A big change came in the mid-1980s when Sea-Land moved to Tacoma, and the port historically changed from bulk cargo to containers. With 70 percent of this container traffic routed out of the area, the Belt Line had a central role to play. In 1998, the Tacoma Municipal Belt Line's name was change to Tacoma Rail to better reflect the role of "Tacoma's own," serving and supporting Tacoma's and the region's economy.

One

SEEDBED FOR ECONOMIC DEVELOPMENT

To better understand the history of Tacoma Rail, it helps to have a little understanding of the city it serves. The Puyallup and Nisqually Indian tribes settled in the area that later became Tacoma, located on the south shores of Commencement Bay. The area was rich in hunting and trapping. Commencement Bay received its name from Lt. Charles Wilkes (1798–1877), who named it in honor of the beginning of his survey of Puget Sound. The first permanent settler was Job Carr in 1864. Carr settled in a lagoon near what was later known as Old Town and called his homestead Eureka.

Two events sparked the growth of Tacoma. The first was the arrival of Morton McCarver in 1868. McCarver was a developer and traveled to Tacoma seeking another fortune. He had the gift of foresight and could envision the development of a port and railhead. He purchased 160 acres of Job Carr's settlement and called it "New Tacoma" in honor of the large white mountain to the southeast that the Indians called Tacoma. Morton immediately set out to attract others to New Tacoma and its deepwater port.

The other event is also credited to Morton McCarver; he was successful in attracting the Northern Pacific Railroad to Tacoma. The Northern Pacific had many suitors in the Pacific Northwest for its western terminus. In those days, attracting the railroad to one's locale insured economic prosperity in an age when dependable transportation was nonexistent. The Northern Pacific envisioned Tacoma as an area rich in natural resources that would need to be transported as well as a jumping-off port for international trade with the Far East.

Northern Pacific made its decision to come to Tacoma in 1873, and the railroad arrived in 1877. This event put Tacoma on the map and cemented the following saying about Tacoma, which is still relevant today: "Where the sails meet the rails." Tacoma's population in 1880 was 1,098, and by 1890, it jumped to 36,006. A fact of history: if Northern Pacific had chosen differently, the Tacoma known today would not exist.

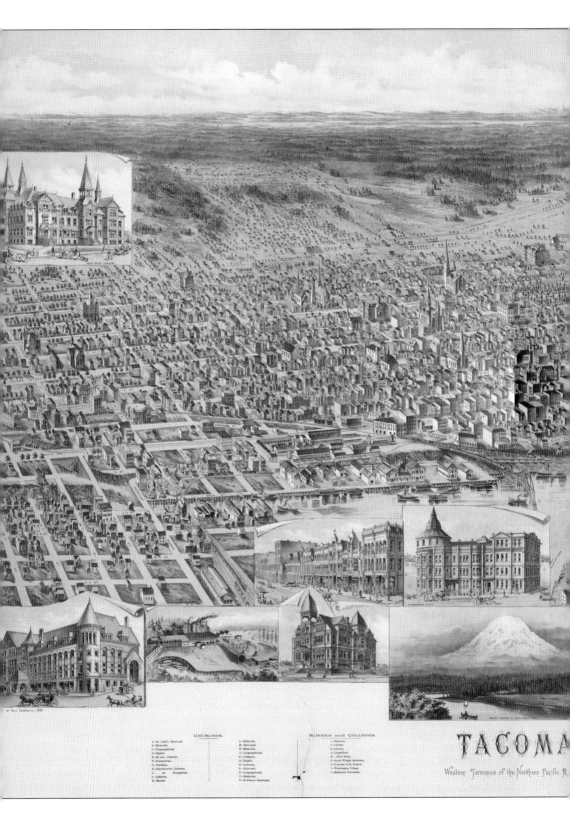

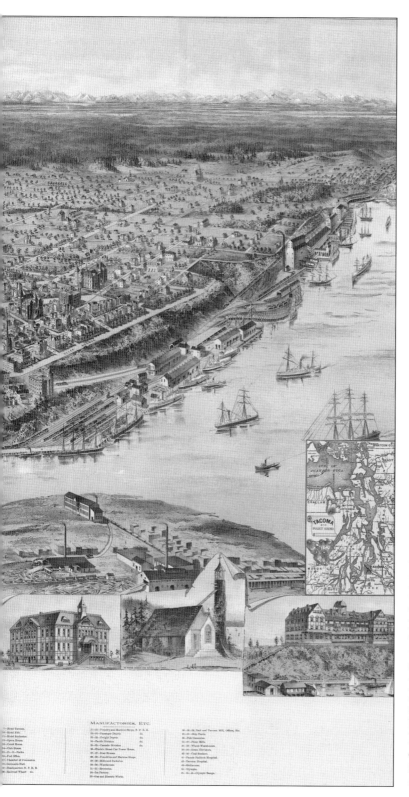

1890 Portrait of Tacoma. This 1890 view of Tacoma clearly reflects the urban sprawl that quickly overtook Tacoma after the Northern Pacific Railroad arrived. Visible in the center along the shoreline are the Northern Pacific yards that wrap around the waterfront. Later, industrial development took place directly to the east of downtown in the Tide Flats after the arrival of the Union Pacific, Milwaukee Road, and Great Northern, breaking Northern Pacific's monopoly on development in Tacoma. (Author's collection.)

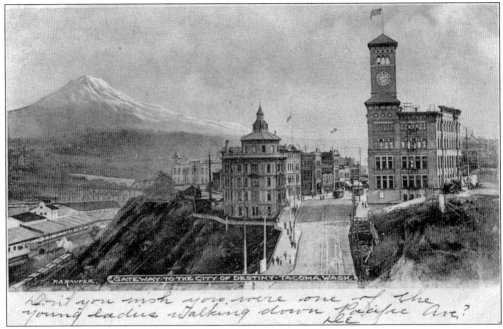

GATEWAY POSTCARD. This early postcard shows the "Gateway to the City of Destiny—Tacoma, Wash." Under the constant shadow of Mount Rainier grows the city of Tacoma. Pacific Avenue is framed by the Northern Pacific Headquarters (at left) and Tacoma City Hall (at right). Northern Pacific erected its headquarters building in 1888. (Courtesy of Tacoma Public Library.)

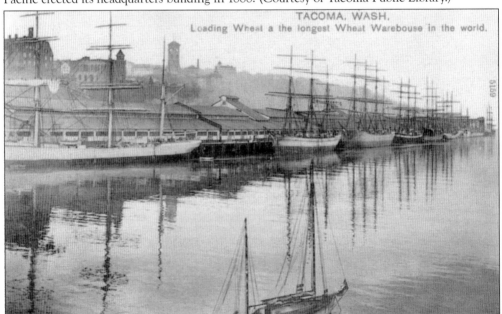

WHERE THE SAILS MEET THE RAILS. In a 1906 Stone and Fisher postcard, ships dock alongside a warehouse complex reputed to be the longest wheat warehouse in the world. The Northern Pacific built these along the City Waterway and had its Half Moon Yard located directly on the other side of the buildings so freight could be directly transferred to the ships. (Courtesy of Tacoma Public Library.)

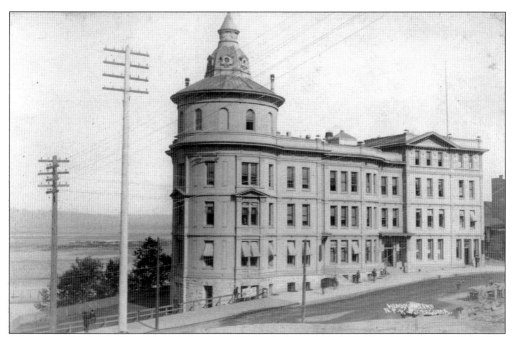

NORTHERN PACIFIC HEADQUARTERS. One of the landmark buildings in downtown Tacoma is Northern Pacific Headquarters. The building was started in 1887 and completed a year later. The structures still stands today but was vacated by the Northern Pacific in 1922. (Courtesy of Tacoma Public Library.)

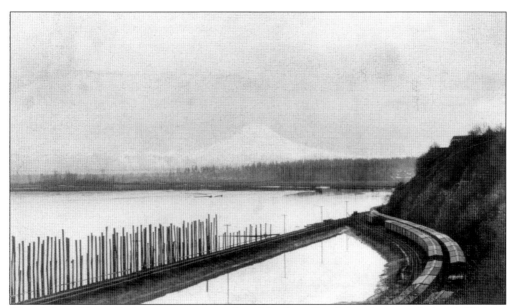

HALF MOON YARD. Early construction work on Northern Pacific's rail terminal, the Half Moon Yard, is pictured here. Construction started in 1885. As with much of the industry on Tacoma's waterfront, it had to be built on fill material brought in and dumped by railcar or horsecar. Pictured here, the tracks are already crowded with freight cars before the yard's completion. (Courtesy of Tacoma Public Library.)

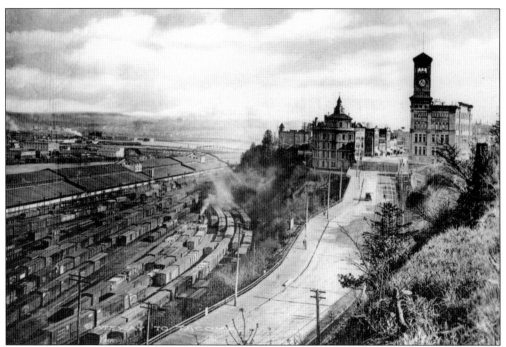

HALF MOON IN OPERATION. This 1907 photograph provides a great comparison to the previous picture on page 13. The yards are filled to capacity. In a view to the east (upper left), one can see development taking place in the Tide Flats, showing the influence of the other national railroads coming to Tacoma. Initially, Northern Pacific bottled up the waterfront confining development next to its tracks. (Courtesy of Tacoma Public Library.)

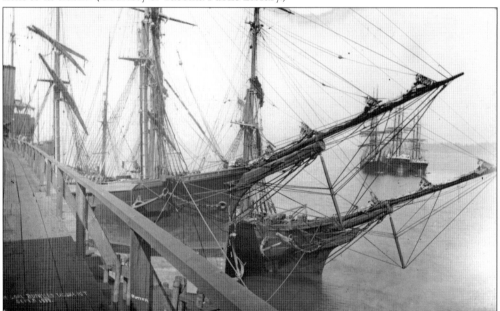

EARLY TACOMA WATERFRONT. In an 1888 photograph, two ships tie up to coal bunkers located on the waterfront close to present-day Old Town. For a short period of time, Tacoma was a leading coaling station on the West Coast. (Courtesy of Tacoma Public Library.)

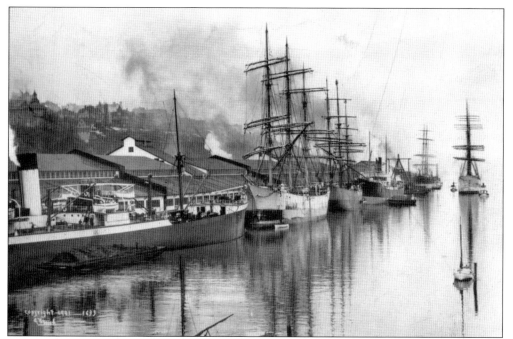

CROWDED WATERFRONT. In this 1901 picture, ships crowd the docks next to Northern Pacific's Half Moon Yard and associated warehouses. It appears that the original vision of Morton McCarver came to fruition with international trade clearly underway. (Courtesy of Tacoma Public Library.)

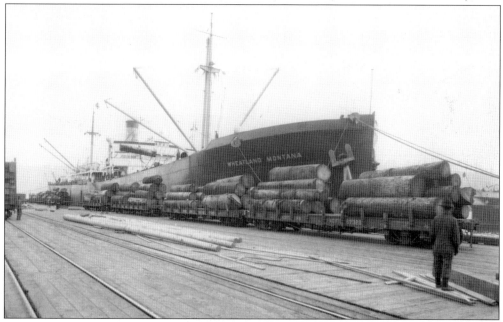

EARLY IMPORTS. As export trade was flourishing, so did imports. Here, the *Wheatland Montana* is unloading mahogany logs from the Philippines. These logs had to be loaded onto flatcars and then transported into the Tide Flats area for fine finishing work. Because of their extreme weight, the logs could not be floated. The photograph is dated March 30, 1925. (Courtesy of Tacoma Public Library.)

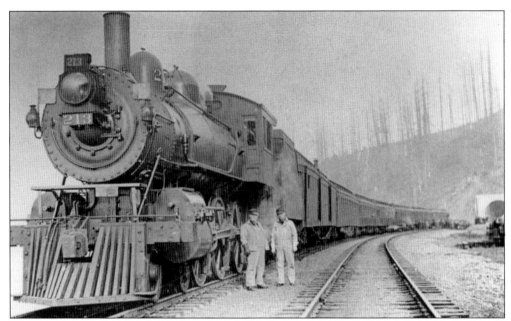

NORTHERN PACIFIC. The railroad's 1873 decision to make Tacoma its western terminus forever marked Tacoma on the map. In a day when industry and big business seemed to come under a dark cloud, it should be remembered that if the railroad had not come to Tacoma, there would be no Tacoma or jobs. (Courtesy of Tacoma Public Library.)

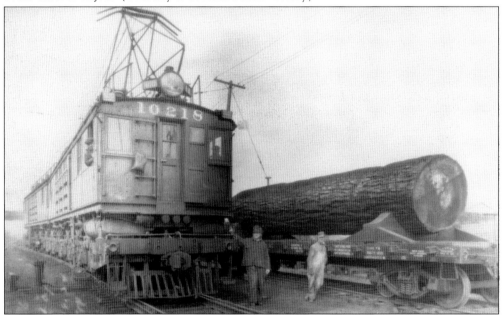

CHICAGO, MILWAUKEE, ST. PAUL & PACIFIC (MILWAUKEE ROAD). In 1905, the directors of the Milwaukee Road decided to build the extension to the Puget Sound region of Washington State. At this time, the railroad had reached North Dakota. By 1909, the line was opened for operation. The Milwaukee had a sizable terminal in Tacoma, including extensive shops located in the Tide Flats. The Milwaukee also gained access to some of the best timberland in western Washington through control of the old Tacoma Eastern Railroad. (Courtesy of Tacoma Public Library.)

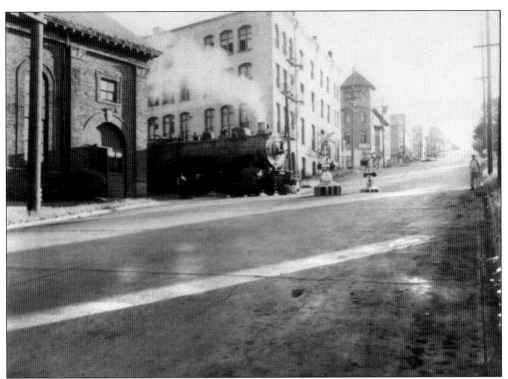

GREAT NORTHERN. By 1910, Great Northern was operating to Tacoma mainly via trackage rights. This photograph shows a train crossing South Nineteenth Street in downtown Tacoma on the Northern Pacific Prairie Line. Many of these buildings are now part the University of Washington Tacoma campus. The Swiss Tavern is seen in the background. (Courtesy of Tacoma Public Library.)

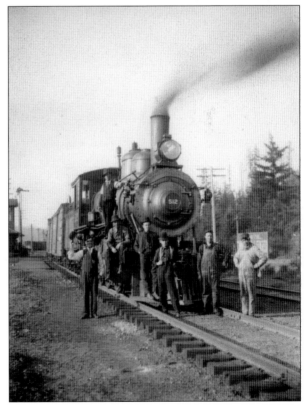

UNION PACIFIC. The Union Pacific Railroad originally accessed Washington State and Tacoma via the Oregon-Washington Railroad and Navigation Company, which later became the Oregon-Washington Railroad. Union Pacific had a failed attempt to build to Tacoma in 1890 from Portland and later obtained Tacoma through trackage rights over the Northern Pacific and Milwaukee Road. (Courtesy of Tacoma Public Library.)

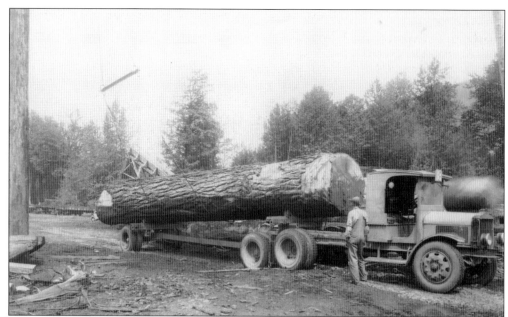

UNLOADING LOG TRUCK. This June 5, 1936, photograph from the Marvin D. Boland Collection of Tacoma Public Library shows a log truck being unloaded at the railhead in Morton, Washington. From here, the log would be loaded on railroad flatcars to be transported to the Tide Flats in Tacoma for processing or export. Logs and lumber would be a mainstay for Tacoma area rail transportation well into the 1980s. (Courtesy of Tacoma Public Library.)

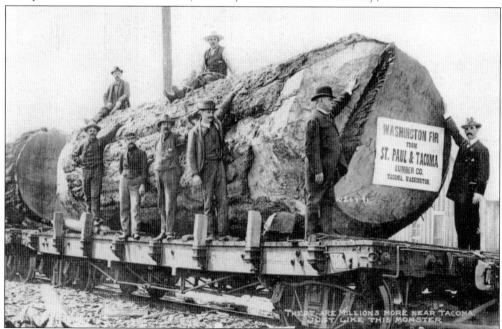

MONSTER LOGS. The caption reads, "There are millions more near Tacoma just like this monster." This 1907 photograph shows a fir log on its way to St. Paul and Tacoma Mill in the Tide Flats to be made into shingles. Like the caption reads, the region was rich in lumber resources. (Courtesy of Tacoma Public Library.)

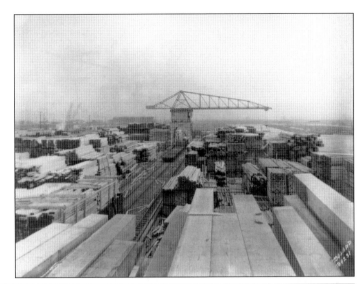

OVERSEAS MARKET. Piles of varied grades of finished lumber for export overseas crowd this 1924 scene. While most of the lumber was destined for China and Japan, a large portion was for domestic East Coast ports. Early in Tacoma's history, Tacoma was known as the lumber capital of the world. (Courtesy of Tacoma Public Library, Marvin D. Boland Collection.)

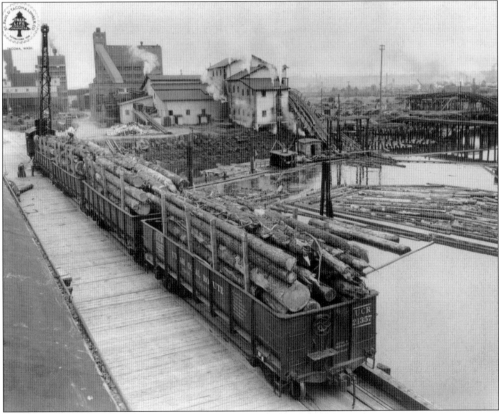

CARLOADS OF RAW LUMBER. This picture is from the *Tacoma News Tribune* of August 14, 1946. Loads of raw lumber are at the "dump" at St. Paul and Tacoma Mill, located in the Tide Flats. Founded in 1888, it was one of the largest mills in Tacoma. St. Paul owned 80,000 acres of forest in Pierce County. This land was purchased from Northern Pacific land grants. At one time, St. Paul ran over 50 cars a day of raw lumber through its mill for processing. (Courtesy of Tacoma Public Library.)

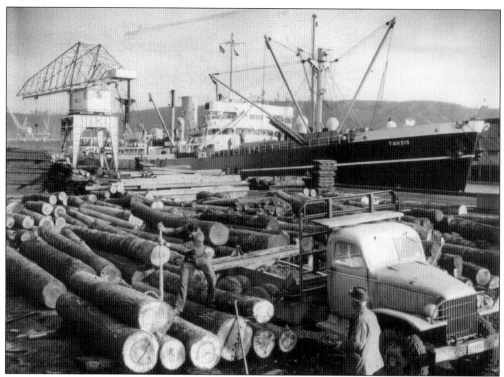

LOADS FOR STEAMSHIP TAHSIS. Tacoma docks are crowded with different forms and grades of lumber; the lumber is in the process of being loaded onto the steamship *Tahsis*. Lumber was the king of commodities in Tacoma until the decline of the area's lumber industry in the 1970s and 1980s. (Courtesy of Tacoma Public Library.)

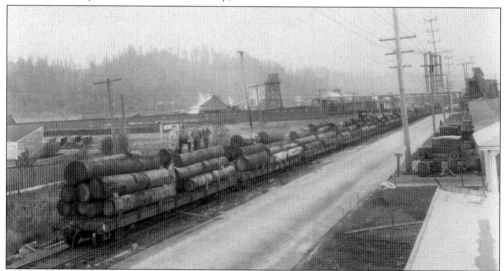

IMPORTED HARDWOODS FOR BUFFELEN. Shown are flatcars of hardwood mahogany; the wood was imported from the Philippines to Tacoma's Buffelen Lumber and Manufacturing, located in the Tide Flats. Buffelen manufactured doors and plywood and other specialty wood products. During this time, there were over 100 businesses in the region dedicated to processing lumber. (Courtesy of Tacoma Public Library.)

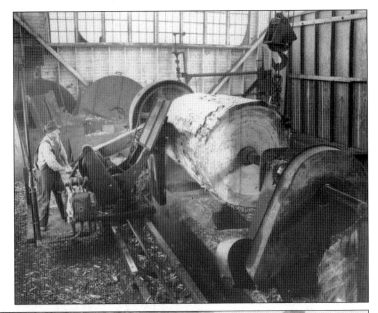

PEELING RAW LUMBER. Here, a worker is peeling raw lumber at Buffelen Lumber and Manufacturing for the making of plywood. This machine rotates the lumber and peels it for plywood manufacturing. Plywood was used extensively in the housing boom following World War II. (Courtesy of Tacoma Public Library.)

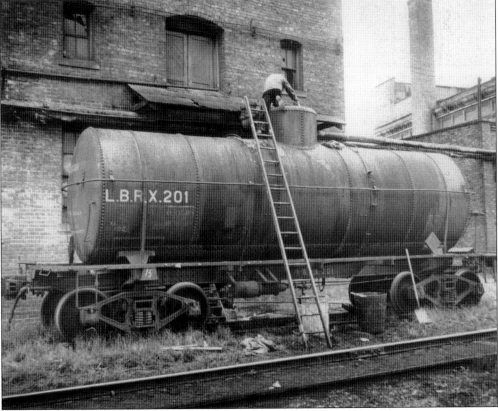

TANK CAR CLEANUP. Another industry that had a large impact on Tacoma's rail lines was the chemical industry. With cheap power, water, and transportation all readily available, Tacoma was an ideal site for the manufacture of chemicals. This picture is actually of a spill from a leaky valve on a tank car at National Soap. (Courtesy of Tacoma Public Library.)

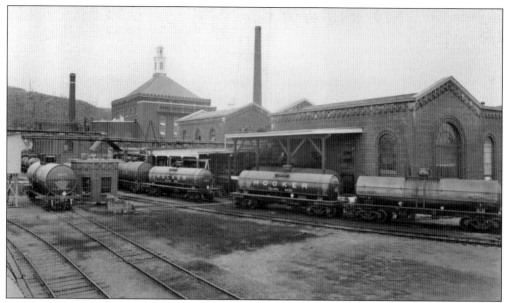

HOOKER CHEMICAL. Here, tank cars wait to be loaded and shipped out. The Hooker Electrochemical Company opened in Tacoma in 1929. This particular plant was served by barge and rail. It produced chlorine and caustic soda in support of the Northwest's paper industry. (Courtesy of Tacoma Public Library.)

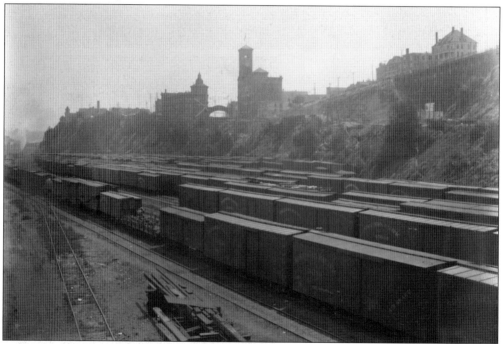

EARLY HALF MOON YARD. This 1908 image of Northern Pacific's Half Moon Yard is from the Amzie Browning Collection, Tacoma Public Library. It shows the switchyard crammed full of boxcars. Half Moon Yard was the staging yard for Northern Pacific's traffic to and from Tacoma. The Northern Pacific Headquarters and Tacoma City Hall are very prominent in the upper center of the photograph. (Courtesy of Tacoma Public Library.)

SPERRY FLOUR COMPANY. Sperry Flour, a division of General Mills, was located along the waterfront on the Northern Pacific. Grain exporting, as well as milling, was another substantial industry served by Tacoma's railroads and shipping. Prior to World War II, Tacoma was the largest grain-milling center west of Minneapolis. (Courtesy of Tacoma Public Library.)

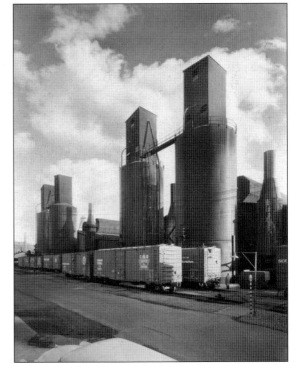

OLIN ALUMINUM. Aluminum production requires an inexpensive source of electricity. Power was provided by the abundant hydroelectric power in the region, and the dependable rail transportation helped with the distribution of aluminum. Kaiser Aluminum invested $3 million to upgrade the plant in 1952. (Courtesy of Tacoma Public Library.)

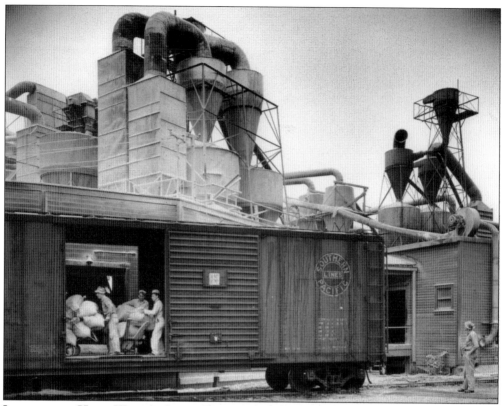

LOADING THE HARD WAY. At Sperry Flour, workers load 100-pound bags of flour into railcars for shipment all around the country. Tacoma's national ranking in the milling industry was in decline due to government pricing controls and the availability of inexpensive grains. Sperry closed by 1965. (Courtesy of Tacoma Public Library.)

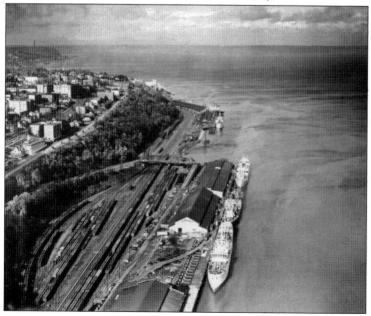

AERIAL VIEW OF HALF MOON. In an aerial view of Half Moon Yard and the surrounding region, one can see the changes that have occurred. Ships still call on the warehouses along the waterfront, but the yard does not seem as crowded. Changes were coming to Tacoma as industries came and went, but Tacoma would always hold its title—"Where Sails Met the Rail." (Courtesy of Tacoma Public Library.)

Two

Trolley Town

By the 1880s, it was apparent that Tacoma needed some form of public transportation for its expanding population. In 1887, Tacoma City Council granted a 50-year franchise to Nelson Bennett (famed builder of the Northern Pacific Railroads Stampede Pass Tunnel). This line was known as the Tacoma Street Railway. It opened the floodgates for more applications for street railway franchises; however, most never made it past the "paper" stage.

In a few short years, over 16 routes radiated out of Tacoma. These included Steilacoom Line, Wapato Park, Lake City, American Lake, Fern Hill, and Point Defiance, just to name a few. At this time, the city recognized a need for a line to the Tide Flats to meet the need of the growing industry in this region.

Tacoma built the Eleventh Street Bridge to link downtown Tacoma with the Tide Flats to spur growth and access. However, because of the financial risk involved, no company would come forward to build this line. In 1912, a proposal for the city to build the line was floated. The proposal came to fruition in 1914 with an agreement between the city and the Tacoma Railway and Power Company (TRP). The city would build the line, and the TRP would operate it under contract with the city. On June 10, 1915, the first trolley ran from Pacific Avenue to the Milwaukee Road car shops, a distance of 1.25 miles.

In 1917, the city took over operations of what became the Tacoma Municipal Street Railway (Muni Line). Since the city could find no investors, city public works and, later, city light were designated to own and operate the line as a service for the expanding industry in the Tide Flats. By 1925, the name was changed to Tacoma Municipal Belt Line, after its switching operation. The trolleys were never moneymakers and they continued to lose money and be a drag on the switching operation. Tacoma looked for alternatives.

In 1927, the first buses arrived. The buses were quickly seen as a more efficient form of transport. Routes could be changed as needed without changing the infrastructure. By 1938, the last trolley on the Belt Line ran its final miles. Tacoma's 50-year fling with trolley cars came to an inglorious end. The buses did little to stem hemorrhaging financial loss of running passengers to the Tide Flats, and the bus operation was turned over to Tacoma Transit on January 1, 1947.

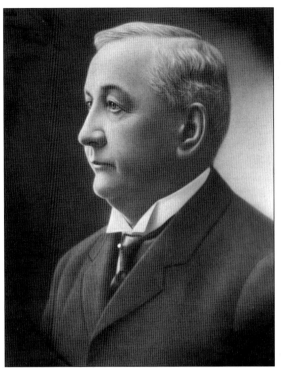

NELSON BENNETT. Nelson Bennett was born in Canada in 1843. Nelson had a distinguished career. He built Army barracks, drilled for oil, taught school, fought Indians, and mined. He was known more locally for his work on the Northern Pacific Railroad on Stampede Pass. Nelson was also the founder of the Tacoma Street Railway Company, the first trolley line in Tacoma, built in 1888. (Courtesy of Tacoma Public Library.)

EARLY TROLLEY. This 1905 picture shows an early Tacoma Railway and Power Company trolley. The TRP succeeded in absorbing many of the other weaker lines in Tacoma. Most cars were crewed by an operator and a conductor. (Courtesy of Washington State History Museum.)

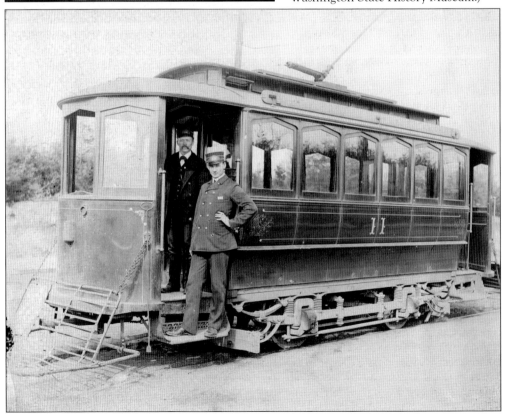

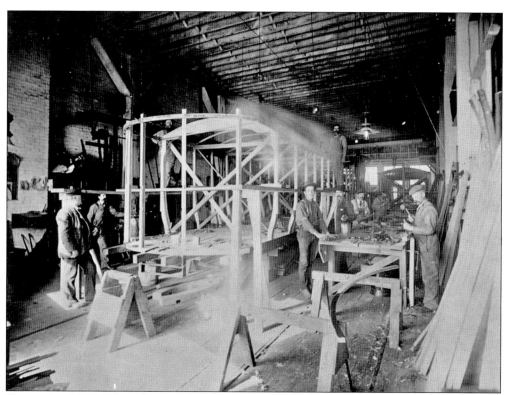

UNDER CONSTRUCTION. This undated photograph shows a trolley car under construction. Many individual lines owned shops and built trolley cars. There were also national manufactures such as Brill that built trolleys and interurbans for lines across the country. (Courtesy of Tacoma Public Utilities.)

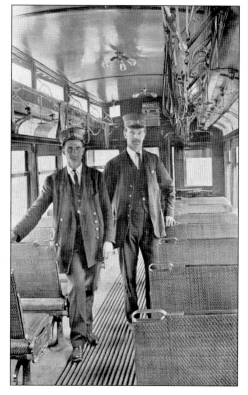

TROLLEY CONDUCTORS. Two Tacoma trolley conductors are seen in their car. The conductor's job was not only to collect fares but also to call out stops and assist the patrons and operator as needed. (Courtesy of Tacoma Public Utilities.)

ARTERIAL TO THE TIDE FLATS. Replacing an older swing span, the Eleventh Street Bridge was opened in 1913 to connect downtown Tacoma with the Tide Flats. The bridge spanned the City Waterway (later named Foss Waterway). In the end, the city built a line from Pacific Avenue into the Tide Flats. Later, this bridge would be the site of a fatal trolley accident. (Courtesy of Tacoma Public Library, Richards Studio Collection.)

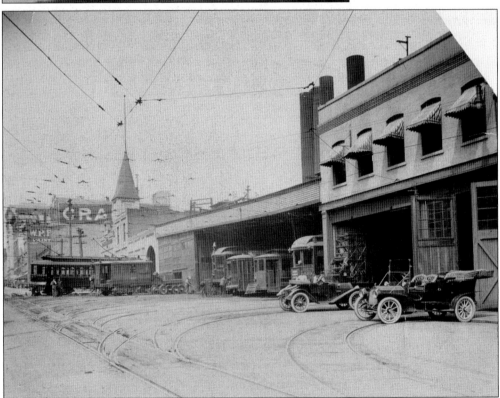

A STREET TROLLEY BARN. Trolley shops were called barns. This is the trolley barn for the Tacoma Power and Railway. Along with its powerhouse, the barn was located at Thirteenth and A Streets. This 1914 photograph shows several pieces of equipment parked in the barn. Here, cars were readied and repaired before and after their services. By this time, the Tacoma Railway and Power Company controlled most of the lines in the city. (Courtesy of Washington State History Museum.)

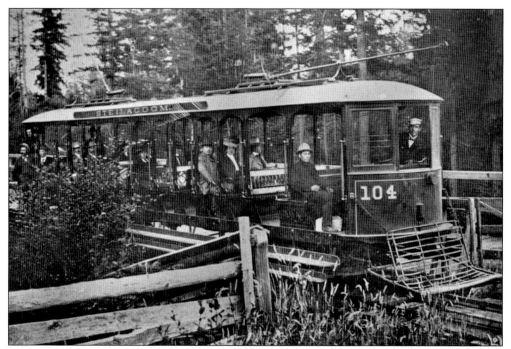

STEILACOOM LINE. The Steilacoom Line was one of Tacoma's older lines. It ran into downtown Steilacoom after running south along the shore of Puget Sound for a ways. Pacific Traction also ran a line that did not quite make it to downtown Steilacoom but stopped at the state asylum just east of Steilacoom's town center. (Courtesy of Tacoma Public Utilities.)

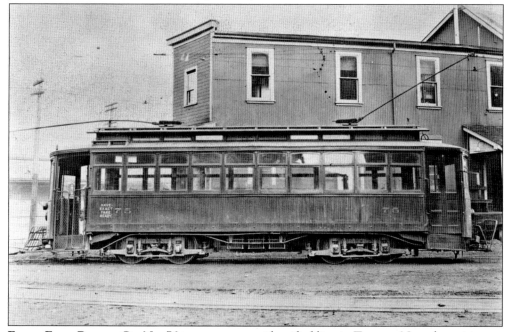

EXACT FARE, PLEASE. Car No. 76 is seen on an unidentified line in Tacoma. Note the writing on the front end: "Have Exact Fare Ready." On some of the trolley lines, riders would refuse to pay and jump off the car to avoid doing so. (Courtesy of Tacoma Public Utilities.)

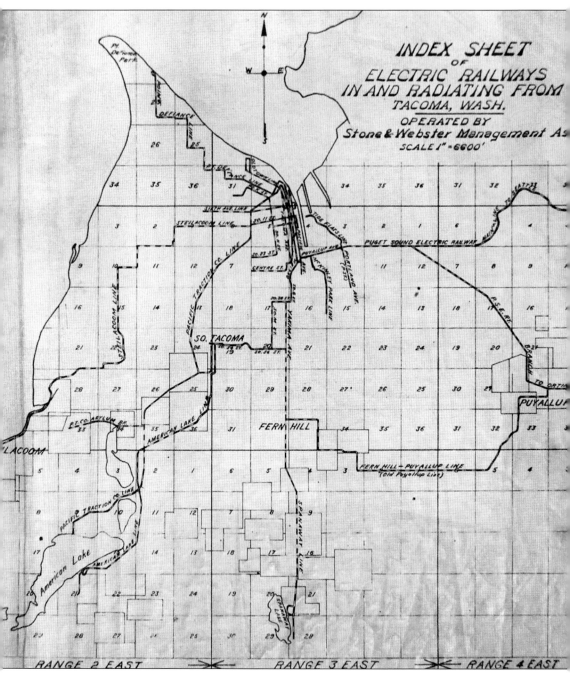

TROLLEY EMPIRE. This is an undated map showing the extant of Tacoma's trolley sprawl to reach the community. There were 120-plus miles of trolley lines in Tacoma at one time. By the late 1930s, it would all be gone. (Courtesy of Tacoma Public Library.)

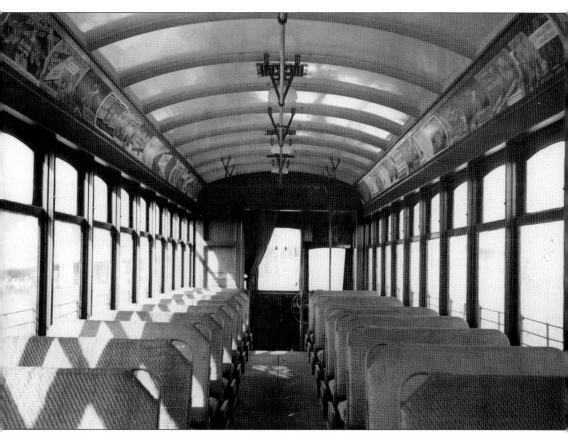

TROLLEY INTERIOR. Here is the spartan interior of one of Tacoma's trolleys. Note the overhead advertisements, which were other sources of income. No visible insulation in the walls makes one wonder what temperature control was like on the trolley cars. (Courtesy of Walt Ainsworth, Warren Wing Collection.)

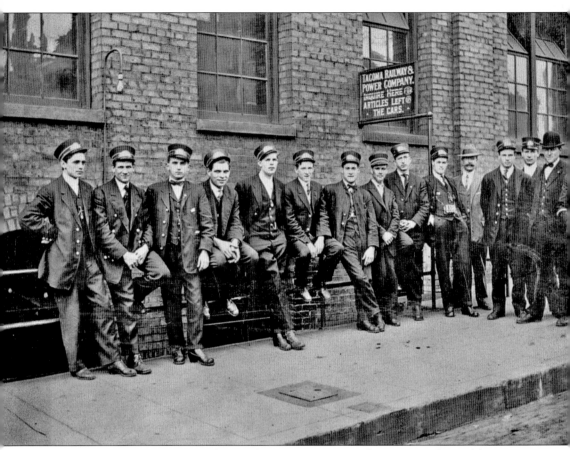

TRP Conductors. Tacoma Railway and Power Company conductors are in front of the company's office at Thirteenth and A Streets. Part of TRP's improved service was a raise in pay for the conductors who often had to deal with an ungrateful public. Many of the trolleys ran on an honor system, which soon proved a failure. Often, the conductors had to deal with passengers who refused to pay. (Courtesy of Tacoma Public Utilities.)

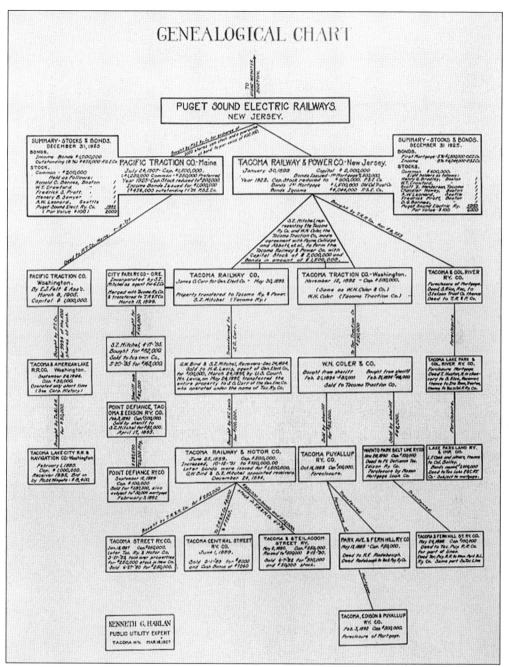

EVOLUTION OF TACOMA TROLLEY LINES. This chart shows the gradual consolidation of the trolley companies in Tacoma. As weak companies failed, healthier companies consolidated them. In the end, all were folded into the Puget Sound Electric Railway, based in New Jersey. (Courtesy of Tacoma Public Utilities.)

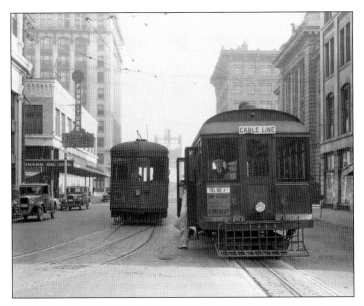

TROLLEY MEETS CABLE. A Muni (soon Belt Line) car rolls next to a Tacoma Railway and Power Company cable car. The Muni car is coming off the Eleventh Street Bridge visible in the background. The cable line ran up Eleventh Street and returned on Thirteenth Street on a large loop. The cable car differed in that it ran on a continuous underground moving cable. Note that there are no overhead wires. (Courtesy of Tacoma Public Utilities.)

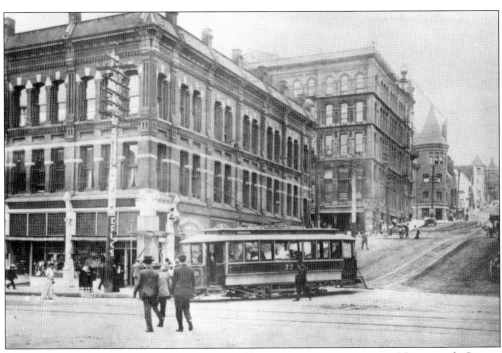

EARLY DOWNTOWN TROLLEY TRAFFIC. A trolley is starting its ascent up Nineteenth Street. This site is now a campus of the University of Washington. The building with the curved side is the Swiss, which was and still is a common downtown hot spot. (Courtesy of Washington State University.)

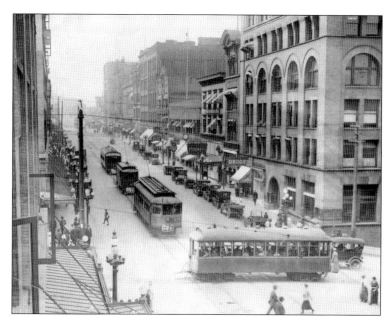

BUSY BROADWAY. This picture, dated 1915, has appeared in many publications. The location is looking northward at Broadway and Eleventh Street. The three trolleys are stopped waiting for the cable car as it ascends Eleventh Street. Automobiles are already competing at this early date for parking space. (Courtesy of Tacoma Public Utilities.)

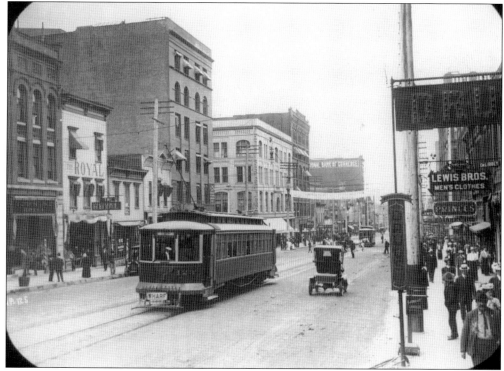

PACIFIC AVENUE LINE. Another busy downtown shot is of a Pacific Avenue Line trolley. This photograph is dated August 1907. This line ran from Seventh Street and Pacific Avenue to Thirty-fifth Street and Pacific Avenue and then switched directions and returned. (Courtesy of Tacoma Public Library, Richards Studio Collections.)

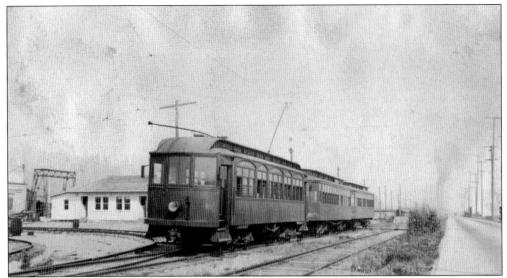

TACOMA MUNICIPAL TROLLEYS IN WAITING. A Tacoma Municipal Street Railway trolley set waits its call. The trolley traffic was busy in mornings and late afternoons. Between hours, most of the train sets were parked until required for morning or afternoon operation. This caused difficulty for the freight-switching operation. (Courtesy of Washington State History Museum.)

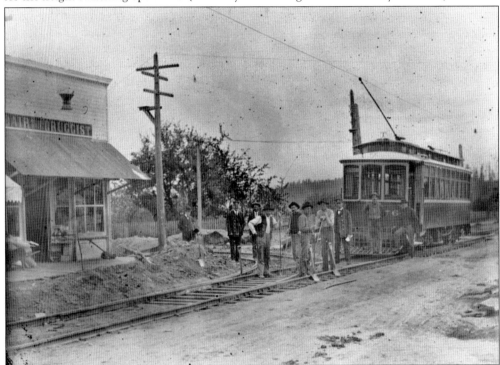

TRACK WORK IN STEILACOOM. The Bair store gives away the trolleys location on the Steilacoom Line before it was folded under the TRP. The track crew is pausing long enough to pose for the photographer. Trolley lines required constant maintenance, mainly due to shoddy, cheap construction. Not only was the track worn, but also overhead wire had to be constantly adjusted. (Courtesy of Tacoma Public Utilities.)

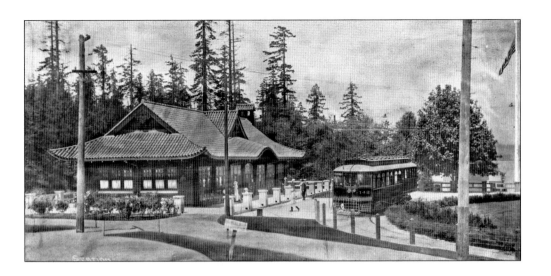

POINT DEFIANCE LINE. Car No. 142 is stopping at a famous Tacoma landmark, the Pagoda. The Point Defiance Line ran from downtown Tacoma seven miles to Point Defiance Park. Point Defiance was a popular destination spot, as it is today, for Tacomans. The Pagoda was at the end of the line and had a waiting room and restrooms for park visitors and car riders. The Pagoda was built in 1914. (Above, courtesy of Tacoma Public Utilities; below, courtesy of Washington State University.)

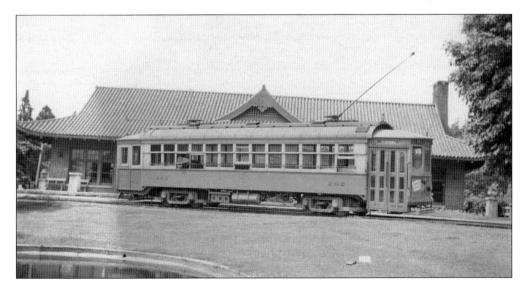

TRAGEDY AT ELEVENTH STREET. On the night of December 30, 1925, the Muni Line Trolley en route to the Tide Flats was crossing eastbound on the Eleventh Street Bridge. The bridge was in the open position. The trolley ran through two barricades designed to warn the trolley that the span was open; the car continued on and fell through the opening, carrying five passengers to their deaths in the icy waters below. Four people, including the operator who jumped before the car ran through the opening, survived. (Courtesy of Tacoma Public Library, Marvin Boland Collection.)

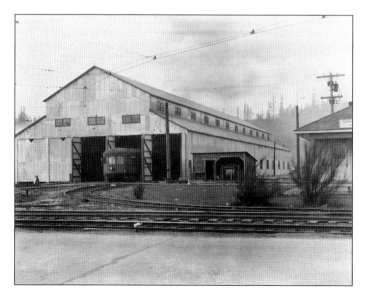

MUNI LINE BARN. The Tacoma Municipal Street Railway barn, located at Eleventh Street and Taylor Way, was the main shop for the Muni Line. On Sunday June 24, 1928, the barn mysteriously burned to the ground in a three-alarm fire. The fire occurred during labor unrest, but nothing was ever proved. The Muni Line lost 22 of 24 cars. The Tacoma Railway and Power Company leased cars to the Muni Line until others could be located.

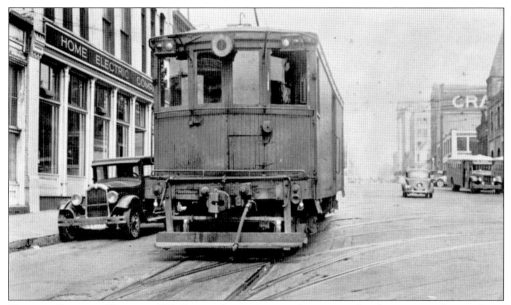

TROLLEY FREIGHT TRAFFIC. While not the mainstay of revenues for the street railways, there was some freight traffic. Tacoma Railway and Power Company had boxcars on its roster. The Puget Sound Electric Railway (successor of all the street railways) had 28 flatcars, 25 boxcars, 10 gondolas, and 3 cabooses. Freight traffic on most of the street railways consisted of smaller LCL (less than carload) traffic, such as express deliveries to locations along the line. There was some heavier traffic with construction material, like brick. Most lines could not handle heavy carloads due to the light infrastructure and low horsepower. The Belt Line did roster electric switching locomotives that were used in the Tide Flats. Two of the Belt Line's electrics formerly worked for the Puget Sound Electric Railway before their stint on the Belt Line. (Above, courtesy of Tacoma Public Utilities; below, courtesy of Tacoma Public Library.)

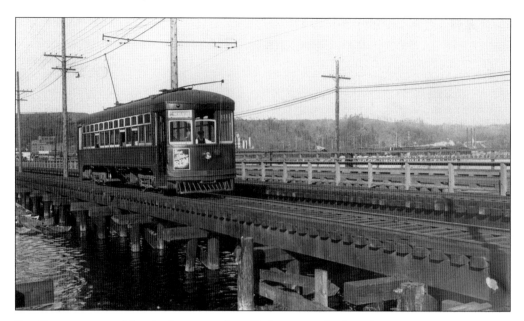

FIRE REPLACEMENTS. After the destructive fire of Belt Line's trolley barn (page 38), seven replacement cars were purchased from Perry, Buxton & Doane Co. of Boston. These cars arrived in various conditions that required extensive, if not complete, overhauls. After negotiating, Perry, Buxton & Doane agreed to cover the renovation of the cars. These cars and the two survivors of the barn fire remained the backbone of the Belt Line's trolley operation until the end. Car No. 6 is seen scooting across a wood trestle in the Tide Flats. Early on, the Belt Line was referred to as the "Step Child Utility." This was due to its difficult financial standing from the money-losing passenger operation. (Both, courtesy of Walt Ainsworth, Warren Wing Collection.)

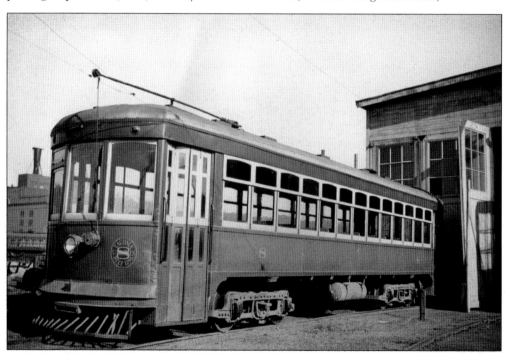

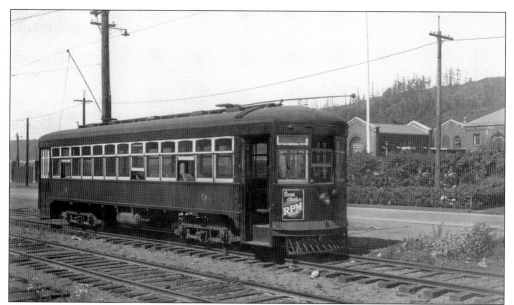

PERPETUAL MONEY LOSER. Car No. 9 is running in the Tide Flats. While the Belt Line passenger trolleys met a need serving the Tide Flats commuting public, they never made money. Fares did not cover the operations or upkeep. Much of the track was in need of replacement or repair. It was becoming apparent to city council and the utility board that another alternative would have to be found. The one bright spot for the Belt Line was the freight-switching operation. In another view, car No. 9 is seen outside the new replacement shop and offices built on the same location as the old barn that had burned down. (Above, courtesy of Walt Ainsworth, Warren Wing Collection; below, courtesy of Tacoma Public Utilities.)

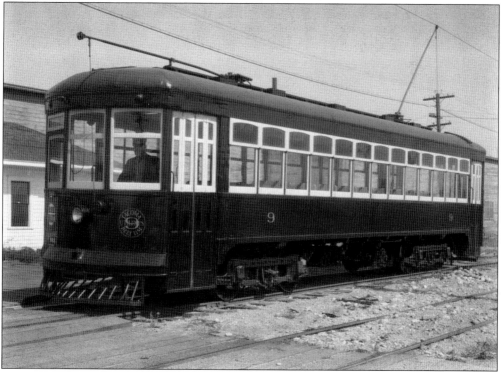

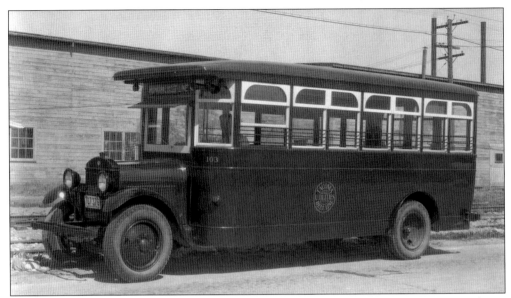

COMING CHANGE. In 1927, the Belt Line purchased two 18-passenger jitneys to serve northeast Tacoma. These two buses were operated in conjunction with the Belt Line trolleys to make a connection in the Tide Flats and then run up to the northeast Tacoma Norpoint area. The buses quickly demonstrated operating efficiencies the trolleys could not match. (Courtesy of Tacoma Public Utilities.)

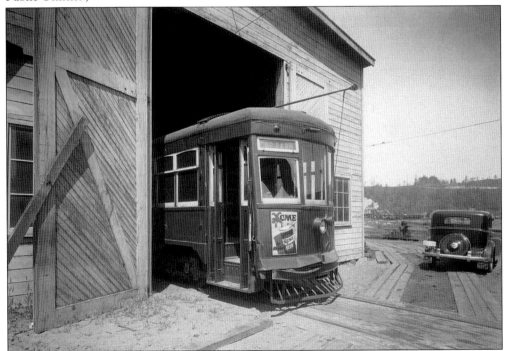

DERELICT OPERATION. Damaged car No. 8 sticks its nose out of the Belt Line's replacement shop. The damaged car does a good job portraying the troubled passenger operation in the Tide Flats. The system was overburdened by debt and, apart from its switching operation, showed no promise of turning its financial situation around. (Courtesy of Tacoma Public Utilities.)

TICKETS. Trolley tickets for the Tacoma Railway and Power Company are shown here. Note the three different lines—Pacific Traction Line, Center–Old Tacoma Line, and Portland Avenue Line. The different stops along the routes are listed in the middle of the tickets. The next section of the tickets shows other lines that can be transferred to from the ticketed route. (Courtesy of Washington State History Museum.)

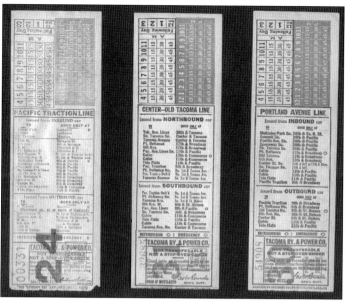

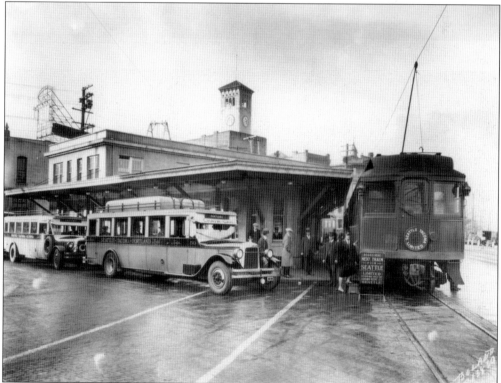

BUS VS. TROLLEY. From the Marvin Bollard Collection, Tacoma Public Library, comes this outstanding December 1925 photograph of buses and trolleys in the shadow of Tacoma City Hall. Here, buses meet the Puget Sound Electric Railway's Seattle train. The buses ran from Portland to Seattle. Puget Sound Electric Railway was really an interurban, not a trolley. It ran at higher speeds and longer distances. The Tacoma-to-Seattle run was 36 miles. (Courtesy of Tacoma Public Library, Marvin Bollard Collection.)

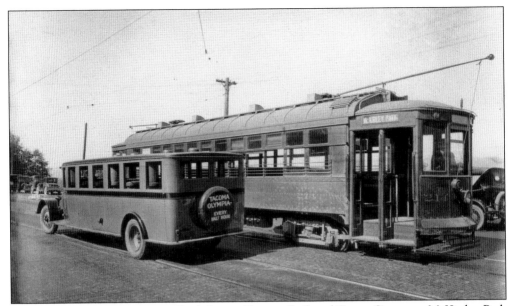

PASSERBY. In a 1924 Marvin Bollard shot, a Tacoma Rail and Power Company McKinley Park Line trolley is passing by a Tacoma Olympia stagecoach. The stage was not in competition with the trolleys as there was no line to Olympia. The McKinley Park Line ran through Tacoma's east side. Eventually, personal automobiles would vanquish the bus system. (Courtesy of Tacoma Public Library, Marvin Bollard Collection.)

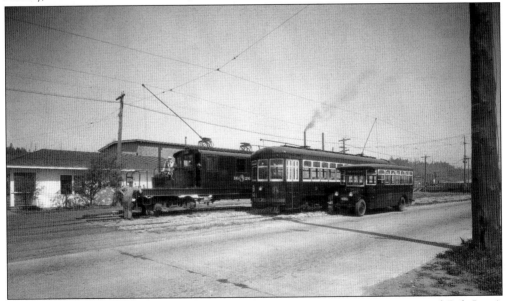

TMBL LINEUP. This photograph documents all the aspects of Tacoma Municipal Belt Line's operations. This must have been a public utilities publicity shot. Pictured on Taylor Way outside of the Belt Line's shop and office building are electric locomotive No. 1626, trolley No. 9, and one of the Belt Line's two jitneys. Of the three modes of transportation, the trolley operation would soon disappear, and the electric locomotive represents the one positive aspect of Belt Line's operation that would go on. The Belt Line's bus service would ultimately be spun off to another operator. (Courtesy of Tacoma Public Utilities.)

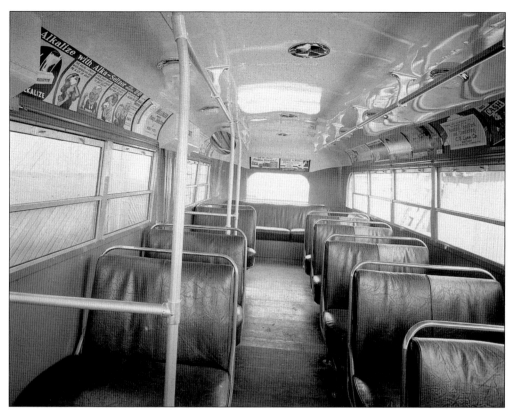

Victor. In the image below, officials, including Belt Line superintendent Charles H. McEachron (far left), pose with the buses that would spell the end of the trolley era in the Tide Flats in 1936. The plug was officially pulled on the Belt Line trolleys in May 1938. The Belt Line had been experimenting with buses since 1927. The buses were far cheaper to operate, requiring no track or overhead wire; they could easily have their routes changed. Also, there was no dispute with the freight operation that must share the same track. (Both, courtesy of Tacoma Public Utilities.)

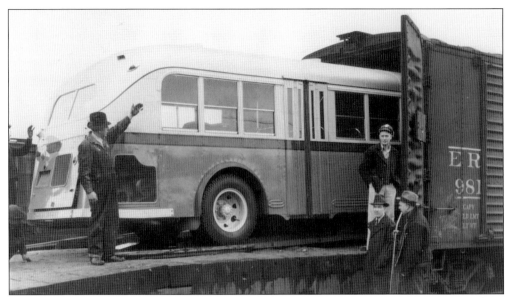

END OF AN ERA. In this February 1938 photograph, the first of 85 buses for the Tacoma Railway and Power Company is unloaded from a railcar. The Twin Coach Company of Kent, Ohio, manufactured these buses. These were purchased by the TRP to replace its aging and expensive-to-maintain trolley fleet. The Tacoma Railway and Power Company was a direct predecessor to Pierce Transit. Like the Belt Line's bus system, the TRP's bus lines would go to Tacoma Transit, which later became Pierce Transit. (Courtesy of Tacoma Public Library, Richards Studio Collection.)

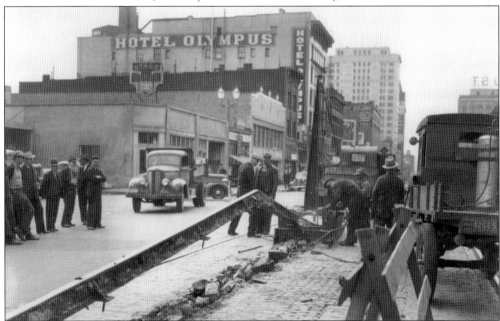

BREAK WITH THE PAST. By April 1938, trolleys were done in Tacoma, as in most of the country. In this view just a year after the trolley's last run, one sees that rail has been removed from the street, marking the end of Tacoma's "trolley fever." At one time, Tacoma and the surrounding region were served by over 120 miles of tracks. Lines were built almost overnight and torn up almost as quickly. (Courtesy of Tacoma Public Library.)

Three
THE MAKING OF THE BELT LINE

As industries thrived in the Tide Flats region of Tacoma, the need arose for a terminal switching line that could connect these industries to the national roads that served Tacoma. Nobody had a better understanding of this than Ernest Dolge. Dolge, himself a mill owner and operator, was unhappy with the half-hearted switching service provided by the Tacoma Municipal Street Railway. The Muni Line's first priority was transportation to and from the Tide Flats. Switching operations were mainly performed at night so as not to interfere with the morning and evening trolley runs. During the day, the single-track line was clogged with parked trolleys waiting for the next rush period.

Using his office, Dolge, the chairman of traffic and transportation with the chamber of commerce, with secretary Jay McCune, met with the national railroads serving Tacoma to encourage their support for a Belt Line Railway in Tacoma. The chamber also sought expert advice in evaluating the city's switching operation. The national railroads agreed to support a terminal railroad in Tacoma. It was in their best interests and would ultimately cost them little to have traffic diverted. On October 29, 1924, Dolge, McCune, officials from the national lines, city officials, and Mayor Angelo Fawcett signed the Tacoma Municipal Belt Line (a name change came a little later) into existence. In 1925, the first full year of operation, the Belt Line showed a profit with its switching operation.

The Belt Line quickly found itself getting clogged up with its newfound success of the switching operation. The national railroads pointed out several discrepancies with the Belt Line's operations that led to this. They suggested additional sidings for storing cars not immediately in use or waiting movement. They also pointed out that the Belt Line lacked an interchange yard that cars could be taken to and from for arrivals and departures. By 1942, Tacoma Municipal Belt Line had 13 miles of track, serving 27 industries in the Tide Flats. During this time, logs and wood products made up 40 percent of the Belt Line's traffic.

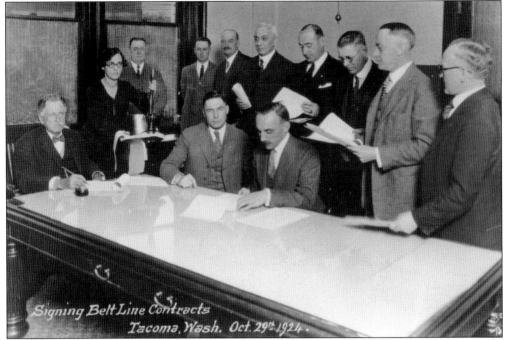

BIRTH OF THE BELT LINE. On October 29, 1924, the Tacoma Municipal Belt Line was signed into existence. Seated at center, Ernest Dolge, the chairman of the Tacoma Chamber of Commerce Traffic and Transportation, is seen putting his signature to paper. In the room witnessing the event are city officials and Mayor Angelo Fawcett (extreme left) and officers from the national railroads that served Tacoma. No single person was more responsible for seeing the Belt Line come to existence than Dolge. The national railroads agreed to support the city's endeavor. (Courtesy of Tacoma Public Library Marvin Boland Collection.)

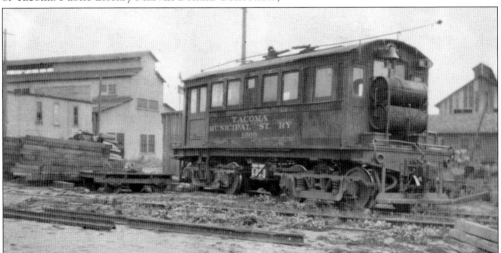

FIRST MOTOR. The Belt Line's switching operation dates back to the Tacoma Municipal Street Railways (TMSR) operation in the Tide Flats. TMSR's No. 1000 is believed to be the road's first switching locomotive. Here, it is parked near the foot of the Eleventh Street Bridge out of the way of daytime trolley traffic. Switching operations took place at night to avoid trolley traffic. (Courtesy of Washington State History Museum.)

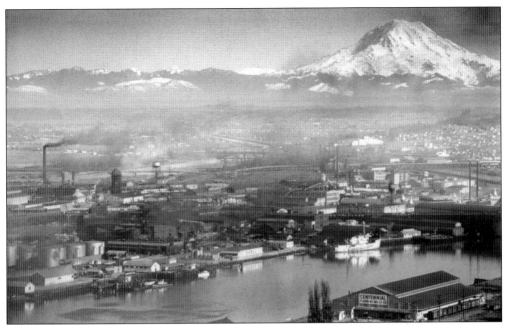

GROWING REGION. Looking across the City Waterway (later Foss Waterway), one can see the expansion that took place in the Tide Flats, home to some of Tacoma's heaviest industries. Development originally started along Tacoma's waterfront next to the Northern Pacific Railroad, but with the arrival of the other railroads and the opening up of the Tide Flats for development, the Tide Flats grew and surpassed the waterfront. This prosperity encouraged growth of the Belt Line. (Courtesy of Tacoma Public Library, Richards Studio Collection.)

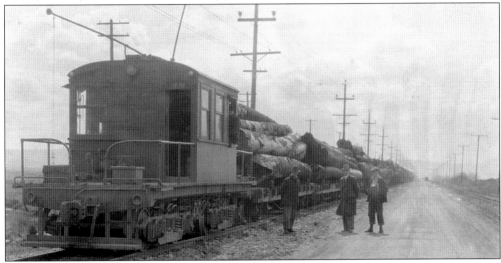

BREAD AND BUTTER. From the start, logs were Tacoma Municipal Belt Line's main traffic commodities. Logs were mostly harvested in the region southeast and southwest of Tacoma. Logs came to Tacoma by rail, truck, and water. Most logs went directly to mills located in the Tide Flats, and others were loaded aboard ships for export to Japan and other countries. Belt Line superintendent Charles H. McEachron is standing in the center of the three men. McEachron was superintendent from 1926 to 1940. He handled the end of the trolley era and the growth of the Belt Line's switching operation. (Courtesy of Tacoma Public Utilities.)

RIGHT-OF-WAY. This early photograph shows the Tacoma Municipal Street Railway right-of-way in the Tide Flats. Most of the track was single-tracked and had to be shared with passenger-carrying trolleys and the switching operation. Lack of coordinated operation, sidings, and a large yard led to difficulties. As the Belt Line came into being, it inherited these problems even after trolley operations ceased. Traffic grew quickly and congested the line, frustrating customers and railroaders alike. (Courtesy of Walt Ainsworth, Warren Wing Collection.)

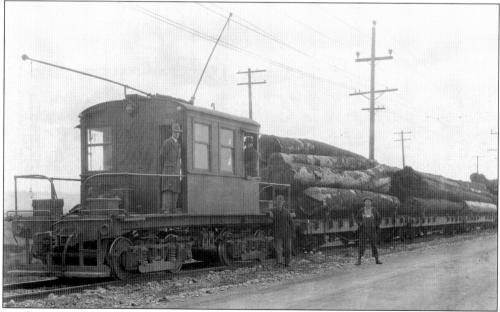

CHARLES H. MCEACHRON. Here is another shot of Charles H. McEachron, standing on the front of the locomotive. Operationally, on McEachron's shoulders fell the responsibility to transform the Belt Line from its past. Even with the eventual discontinuance of the passenger operation, its debt would haunt the freight operation for years to come. (Courtesy of Tacoma Public Utilities.)

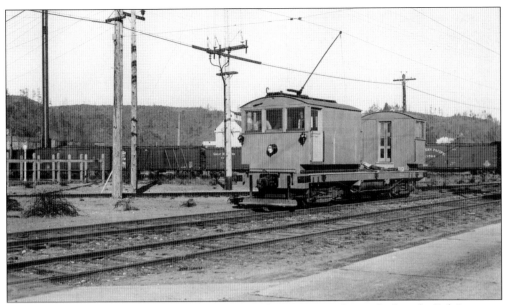

LINE CAR. What looks like a homebuilt affair, the line car reminds people that the Belt Line was still an electric railway. Left over from the trolley era, the Belt Line had three electric locomotives calling for a need to maintain the trolley wire system. (Courtesy of Walt Ainsworth, Warren Wing Collection.)

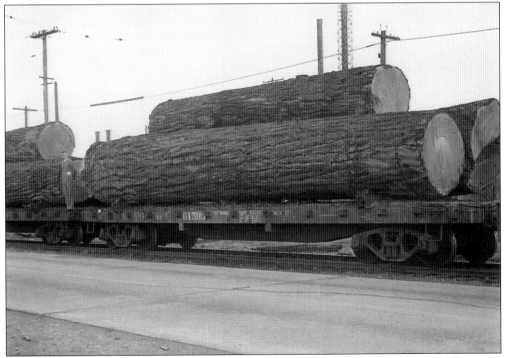

KING LOG. A region blessed by an abundance of soft woods gave rise to the lumber industry, by far the biggest business in the Port of Tacoma. The wood was in demand for manufacturing and building houses across the country. Logs had to be switched to mills for processing. (Courtesy of Tacoma Public Utilities.)

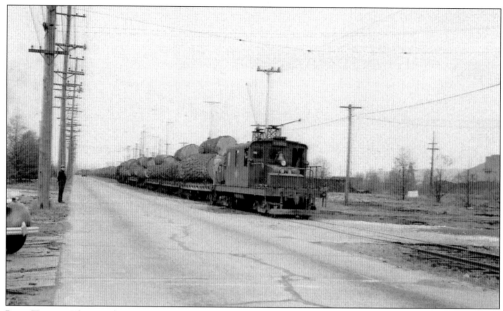

Log Train. Electric locomotive No. 1626 pulls a seemingly endless string of log cars in the Tide Flats. Note the diameter of the logs compared with the man standing on the rear platform of the locomotive. (Courtesy of Tacoma Public Utilities.)

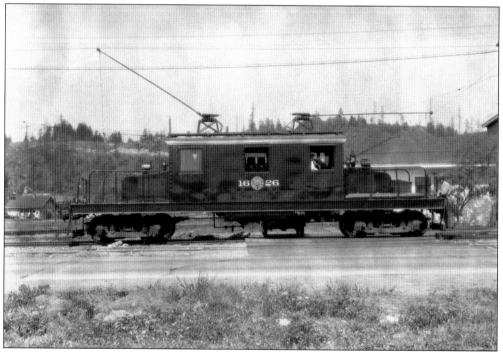

No. 1626. Belt Line freight motor No. 1625, built in 1914, weighed 45 tons and could produce 500 horsepower. The locomotive had four GE 66 motors on Baldwin 74-30 trucks. No. 1626 originally operated on the Puget Sound Electric Railway. It was sold to the Tacoma Municipal Belt Line in 1929 and then sold off to the Skagit River Railway in 1943 with the arrival of the Belt Line's first diesels. It was scrapped in 1954. (Courtesy of Walt Ainsworth, Warren Wing Collection.)

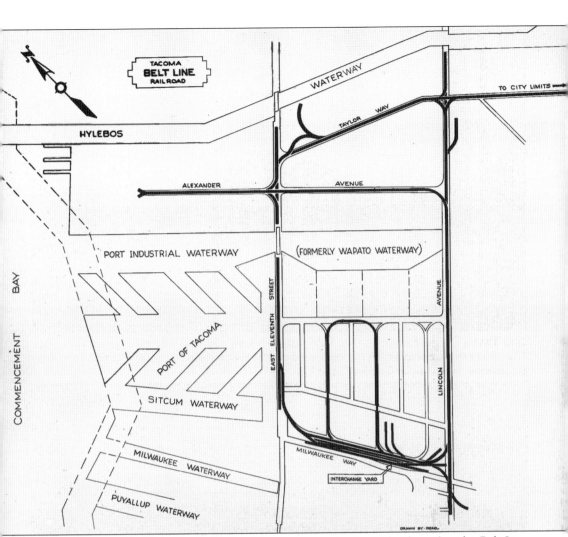

SERVICE AREA. This map shows the freight service area in the Tide Flats after the Belt Line opened its interchange yard located on Milwaukee Avenue following strong suggestions from the national carriers. The last line (not shown in this map) would be the line built around the Hylebos waterway. (Courtesy of Tacoma Public Utilities.)

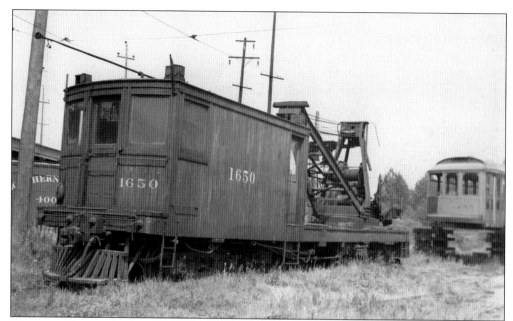

WRECKER. Tacoma Railway and Power Company constructed wrecker No. 1650 in 1910. With the absorption of the TRP into the Puget Sound Electric Railway, it ended up on that roster. The wrecker then went to the Belt Line and was scrapped in 1940. It was homebuilt for trolley wrecks and track service. (Courtesy of Walt Ainsworth, Warren Wing Collection.)

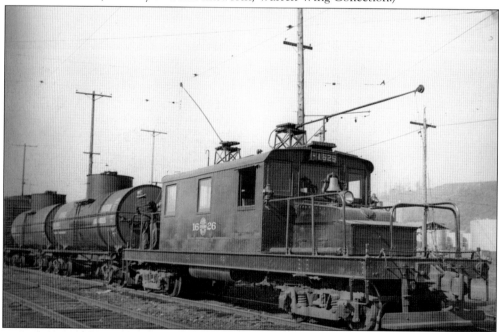

EARNING ITS KEEP. No. 1626 was well suited to the slow-speed drag operation of the Belt Line. Here, it is pulling a cut of varied freight cars. The Belt Line's track was mainly all level, lacking any type of grades that the Puget Sound Electric Railway (No. 1626's original owners) had. No. 1626 was rated at 500 horsepower and could pull over 15 loaded log cars. (Courtesy of Walt Ainsworth, Warren Wing Collection.)

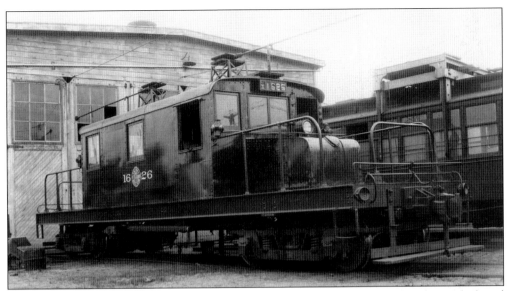

AT REST. No. 1626 is at rest outside of Tacoma Municipal Belt Line's engine house (referred to as a roundhouse). Note the two trolley poles are down and not connected to overhead wire, indicating that the unit is offline either for servicing or off duty. (Courtesy of Walt Ainsworth, Warren Wing Collection.)

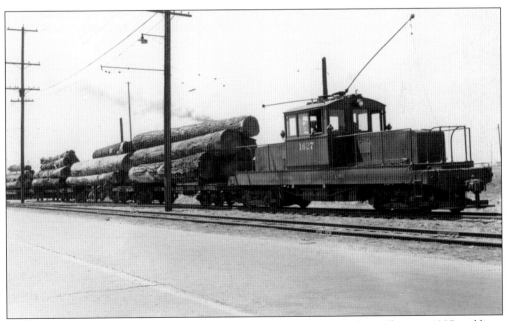

No. 1627. Motor No. 1627 was built by the Puget Sound Electric Railway Shops in 1907 and later extensively rebuilt. In 1929, it, along with No. 1626, was sold to the Tacoma Municipal Belt Line. The motor was rated for 500 horsepower. In 1944, it, as well as the other Belt Line electrics, was sold to the Skagit Valley Railway. (Courtesy of Walt Ainsworth, Warren Wing Collection.)

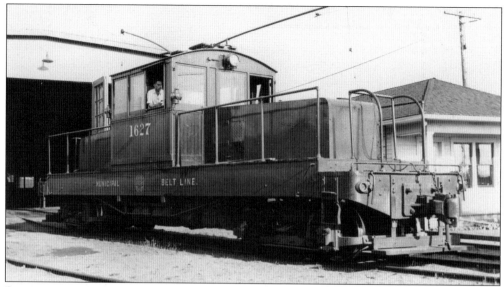

READY FOR SERVICE. Coming out of the roundhouse (note the direction of the trolley pole), No. 1627 is ready to work another shift in the Tide Flats. No. 1627 was originally built without the hoods on each end. After extensive shopping, this was changed. By 1931, Nos. 1627 and 1626 moved over 13,500 cars over the Belt Line. The steeple cab's simple design helped ensure longevity on the Belt Line, but expansion and maintenance of the trolley system would make diesels a more attractive item. (Courtesy of Walt Ainsworth, Warren Wing Collection.)

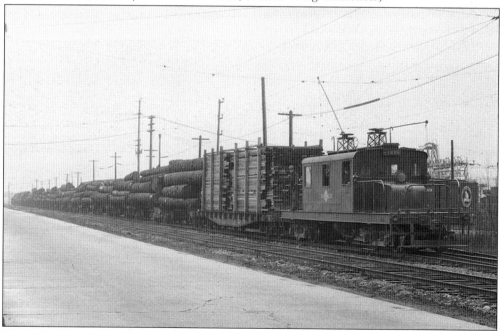

BRUTE FORCE. No. 1626 pulls another string of log cars and one car of finished lumber. The log cars were brought to the Tide Flats either by the Northern Pacific or Milwaukee Road, both of which had lines running into the forested tracts in Pierce and Thurston Counties nearby. The trains were brought down to the Belt Line to be distributed to various mills operating there. (Courtesy of Tacoma Public Utilities.)

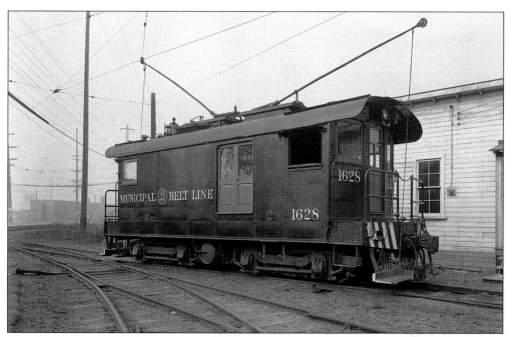

Box Cab No. 1628. Baldwin Locomotive Works built box cab No. 1628 in 1907 for the Spokane & Inland Empire Railway, a subsidiary of the Great Northern. It was sold to the Tacoma Municipal Belt Line in 1927. No. 1628 only produced 300 horsepower in comparison with No. 1626's and No. 1627's 500 horsepower. No. 1628 was also a road engine, not a switcher. (Courtesy of Walt Ainsworth, Warren Wing Collection.)

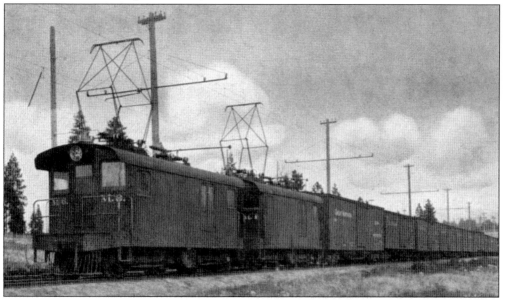

No. 1628's Siblings. A postcard depicts the Baldwin Electrics on Great Northern's Inland Empire. The No. 1628 spent 20 years working for the Great Northern or its subsidiaries before going to the Belt Line. Like all of Belt Line's electric freight motors, it went to the Skagit Valley Railway in 1944 with the arrival of TMBL's first diesels. No. 1628 was scrapped when the Skagit Valley closed down. (Courtesy of Tacoma Public Library.)

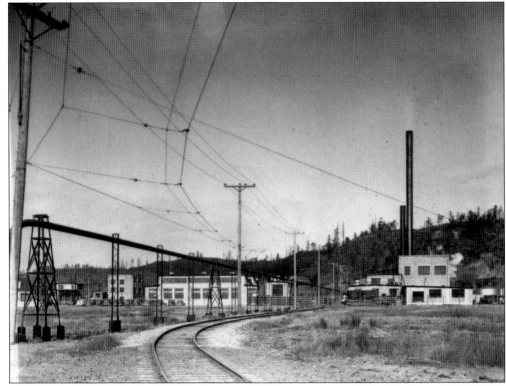

PENNSYLVANIA SALT. Pennsylvania Salt Electrochemical Company was a manufacturer of chlorine and caustic. These chemicals were used in the production of paper and pulp products. This photograph shows the intricate overhead wire and its pole support system for the siding to the factory. (Courtesy of Tacoma Public Library, Richards Studio Collection.)

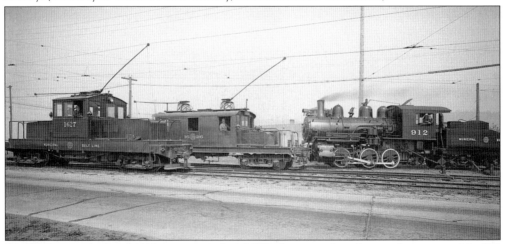

TMBL STEAM. In April 1939, superintendent McEachron purchased steam locomotive No. 912 from the Northern Pacific Railroad. The No. 912 was an 0-6-0 steam switcher of the L-6 class. The No. 912 gave greater operational flexibility and power for the TMBL's switching chores. The arrival of No. 912 started the Belt Line down the road that would replace the electric motors and the supportive infrastructure. Electric Nos. 1627 and 1626 are side by side for this portrait of TMBL's power. (Courtesy of Tacoma Public Utilities.)

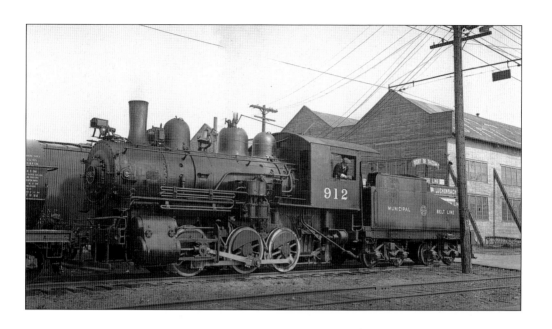

ENGINE NO. 912. Steam switch engine No. 912 was the Belt Line's only steam locomotive. It was originally Northern Pacific's No. 900, built in 1901 and retired in January 1939 and sold to the Belt Line and numbered 912. The class weighed in at 126,000 pounds working weight and could produce 28,200 pounds of tractive effort. The photograph above was taken on March 17, 1947, and the photograph below is dated May 25, 1939. (Both, courtesy of Martin E. Hansen, Al Farrow Collection.)

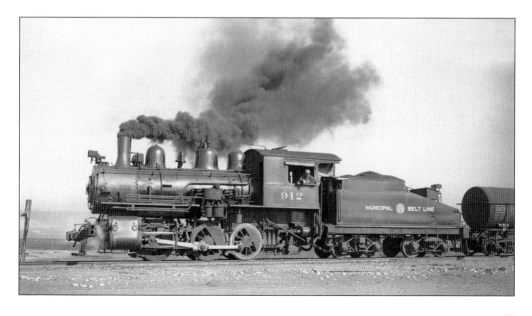

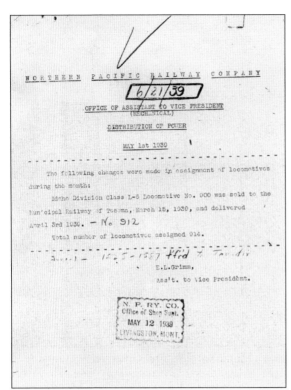

Bill of Sale. Here is a copy of the original order by E.L. Grimm, Northern Pacific Railway's assistant to vice president, transferring steam locomotive No. 900 to TMBL. (Courtesy of PNR Archive.)

Bad Day. No. 1627 is having a bad day, having collided with a truck loaded with fuel wood. The photographer does not comment, but with the slow speed of the electric switching in the Tide Flats, it can be speculated that the truck tried to beat the engine. The accident happened on January 6, 1943. Note Tacoma Municipal Belt Line steam locomotive No. 912 on the scene to assist. (Courtesy of Tacoma Public Library, Richards Studio Collection.)

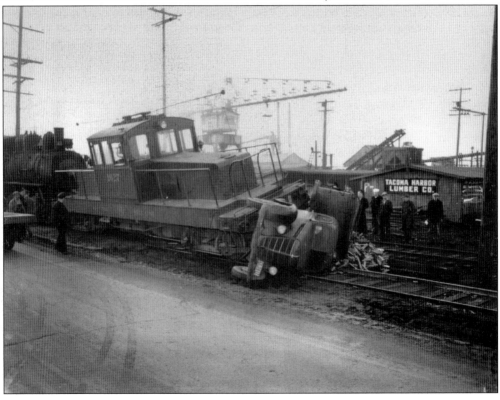

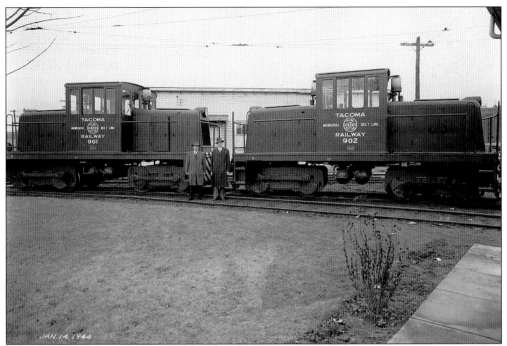

START OF DIESELIZATION. Amos Booth, Tacoma Municipal Belt Line superintendent from 1940 to 1945, purchased two new General Electric 45-ton diesel locomotives in 1944. They were numbered 901 and 902, and they spelled the end of the electric locomotives. The General Electric locomotives were rated at 300 horsepower each. This purchase signaled a new era; Belt Line was making a break with its past trolley association. (Courtesy of Tacoma Public Utilities.)

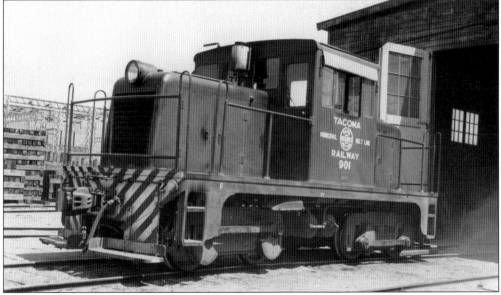

GE No. 901. GE (General Electric) No. 901 is sitting outside the engine house. The GEs were 200 horsepower shy of the 500-horsepower electrics they replaced, but they did not require use of the antiquated overhead wire. Nos. 901 and 902 would exit by 1962, when the Belt Line needed heavier, more powerful locomotives. (Courtesy of Walt Ainsworth, Warren Wing Collection.)

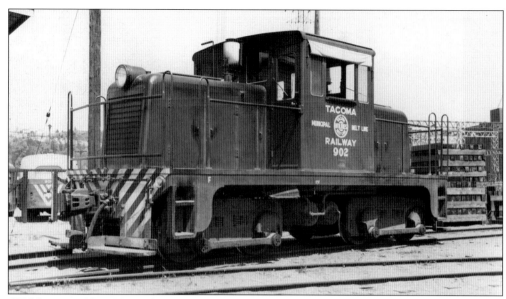

GE No. 902. Nos. 901 and 902 were part of a line of smaller General Electric industrial-size locomotives built around the concept that a small locomotive (44 tons) could be operated by one crew member. Nos. 901 and 902 tipped the scales at 45 tons each. While the locomotives brought an end to the expensive electric operation, they soon found themselves outclassed by the need for larger equipment. Business had been picking up, and the national railroads were operating heavier equipment. At this time, the Belt Line's roster included the two GE Nos. 901 and 902 and the steamer No. 912. (Courtesy of Walt Ainsworth, Warren Wing Collection.)

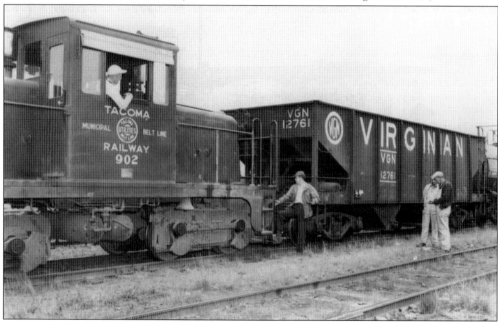

No. 902 at Work. General Electric No. 902 is hooking up to a cut of cars while track crew looks on. This Belt Line photograph was taken post World War II. Traffic and home building increased across the country. This growth directly affected the Belt Line, which served many mills and was still handling log traffic off the Milwaukee Road. (Courtesy of Tacoma Public Library.)

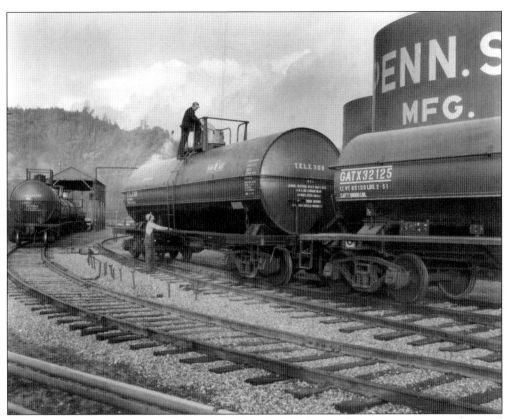

PENNSYLVANIA SALT. One of the industries that grew during the postwar era was chemical production. One of several companies in the Tide Flats was Penn Salt (Pennsylvania Electrochemical Manufacturing). Penn Salt produces liquid chlorine, a mainstay for the region's paper industry. Here, workers prepare a tank car in Penn Salt's tank yard. Liquid chlorine was also used in water plants and sewage treatment. (Courtesy of Tacoma Public Library, Richards Studio Collection.)

LIQUID CHLORINE. Workers prepare a Pennsylvania Salt chlorine tank car for loading inside the Penn Slat Plant, located in the Tide Flats. This plant opened in the 1920s. It manufactured liquid chlorine and caustic soda, both good sources of traffic for the Belt Line. This photograph was taken on October 10, 1951. (Courtesy of Tacoma Public Library, Richards Studio Collection.)

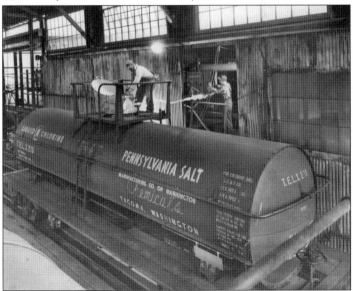

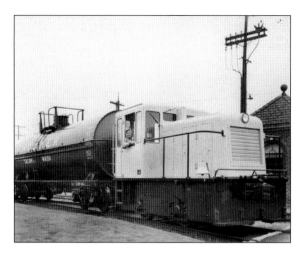

HOOKER CHEMICAL. Another chemical producer that contributed to the Belt Line's bottom line was Hooker Chemical (Hooker Electrochemical). Hooker opened in 1928 and produced three products: liquid chlorine used in bleaching paper and sterilizing water and sewage; caustic soda used in refining petroleum and manufacturing soap; and synthetic ammonia used in the pulp and paper industry and the manufacturing of explosives. Here, a plant switcher moves a tank car within the plant. (Courtesy of Tacoma Public Library, Richards Studio Collection.)

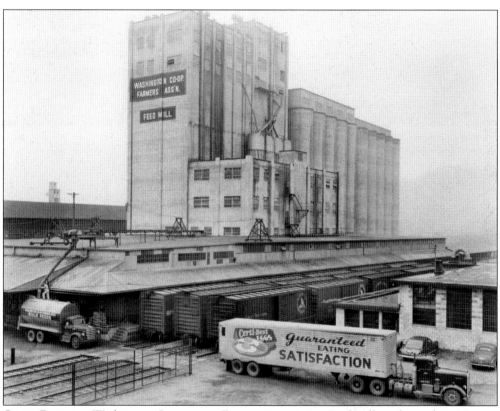

GRAIN BUSINESS. Washington Cooperative Farmers Association Feed Mill was located on 8.5 acres of land on Taylor Way in the Tide Flats. When completed in 1949, it was the most modern grain mill elevator complex in the country. With a capacity of 15,000 tons, it used metal piping inside the structure to distribute different types of grains for mixing. It was built to serve the southwest part of Washington State. Locating the mill in the Tide Flats gave it access to rail, truck, and seagoing transport. (Courtesy of Tacoma Public Library, Richards Studio Collection.)

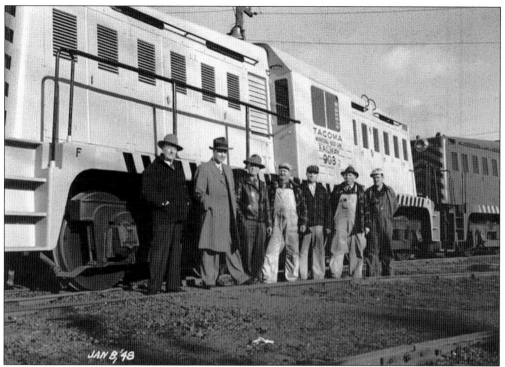

THE WHITCOMBS. In November 1947, Neil H. Kime, Belt Line superintendent from 1945 to 1958, purchased two war surplus Model 65-DE-19 Whitcomb diesel electric locomotives. The engines were purchased to handle the increasing heavy workload of the Belt Line. These locomotives each weighed in at 65 tons and produced 590 horsepower, giving the Belt Line roster a necessary boost. The locomotives were numbered 903 and 904. The arrival of the Whitcombs sent steam locomotive No. 912 to the scrap yard. (Courtesy of Tacoma Public Utilities.)

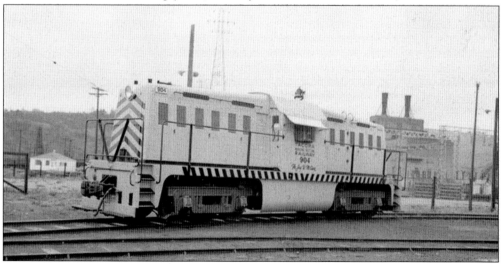

NO. 904, JAY MCCUNE. Whitcomb locomotive No. 904 was named *Jay McCune* in honor of McCune's early work as secretary of the Tacoma Chamber of Commerce. McCune helped map out the Tacoma Municipal Belt Line Railway. The Whitcombs were a plus to the roster even though they were beset with mechanical difficulties. (Courtesy of Tacoma Public Utilities.)

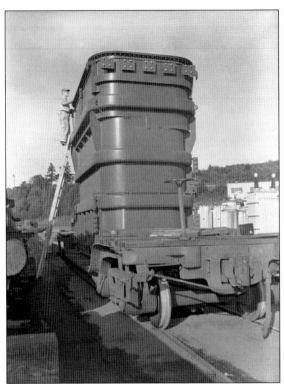

VARYING COMMODITIES. The Tacoma Municipal Belt Line was growing away from many of its traditional commodities. While forest products were still a dominant cargo for the Belt Line, the Belt Line's trains were handling many other products. Chemicals, grains, metals, and food products rounded out the list. Here, a transformer is being unloaded for Tacoma Light in the Tide Flats on a depressed flatcar. (Courtesy of Tacoma Public Utilities.)

LOADING FREIGHT. Workers at Penn Salt are loading barrels of chemical products onto boxcars. The war had strapped the capacities of most of Tacoma's industries and the Belt Line. The majority of Tide Flats industries thrived postwar as the nation experienced an economic surge. (Courtesy of Tacoma Public Library, Richards Studio Collection.)

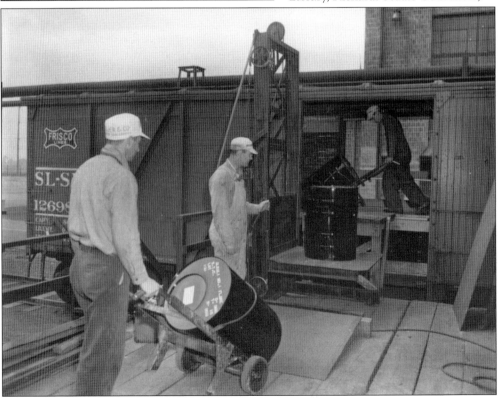

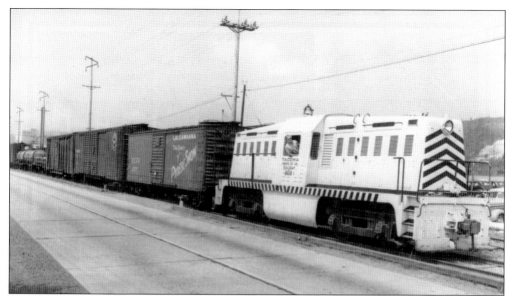

LONG STRETCH. A long stretch of freight cars is seen behind Whitcomb No. 903. The Whitcombs were built for the Army Transportation Corps for use overseas. At the end of World War II, many of the locomotives were brought back and sold to new owners at bargain basement prices. The Municipal Belt Line paid $50,000 for both units. Their 590 horsepower made them the strongest locomotives ever on the Belt Line's roster. It was felt that this was the first time that the Belt Line's locomotive fleet matched its needs. (Courtesy of Tacoma Public Library.)

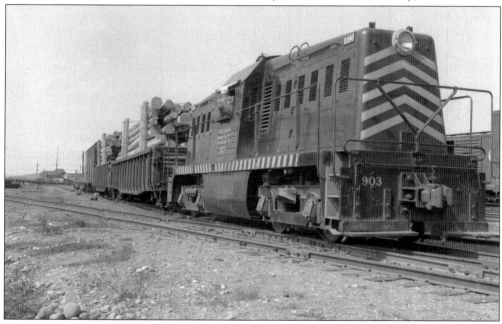

NO. 903 YARD SWITCHER. Whitcomb No. 903 pushes cars into Belt Line's new yard on Milwaukee Avenue. The locomotive's heavy weight (65 tons) and 590 horsepower helped make it an excellent yard engine for pushing and dragging long strings of cars. While the Whitcombs were a welcome addition to the roster, they were a mechanical nightmare for the mechanics and suffered from stress on their frames from their Army years. (Courtesy of Tacoma Public Utilities.)

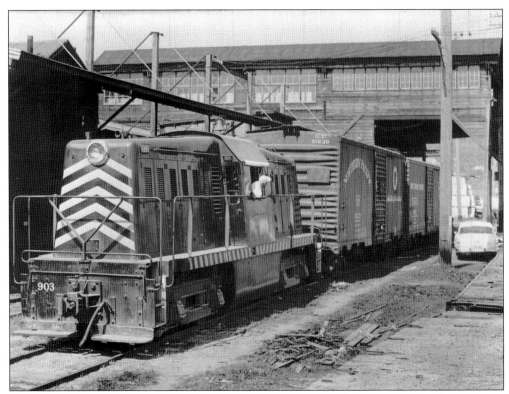

OUT IN THE PORT. Whitcomb No. 903 shoves two boxcars near the port. Not giant locomotives, they could get around tight clearances. The Tacoma Municipal Belts Line's long-standing motto was "the right car, in the right place, at the right time." (Courtesy of Tacoma Public Utilities.)

CRAMPED QUARTERS. Here are Tacoma Municipal Belt Line's cramped office and roundhouse. Located on the site of the original Tacoma Municipal Street Railway trolley barn, this facility was built in 1929 with $7,000 of wood and supplies. The shop and office would serve the Belt Line until new facilities were open in 1969. As the Belt Line grew, this facility was outdated and proved much too small for the roads' needs. (Courtesy of Tacoma Public Utilities.)

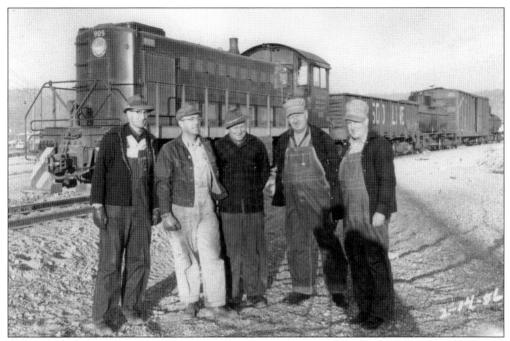

REICHHOLD CHEMICALS. Another large chemical plant served by the Municipal Belt Line was Reichhold Chemicals. Built in 1956 on 51 acres of land in the Tide Flats, Reichhold produced glues for the plywood industry and wood preservatives. Locomotive No. 905 was the Belt Line's newest power, purchased by superintendent Neil Kime in December 1950. This was an Alco S-1 switcher built in March 1950 as an Alco Demonstrator unit. It weighed 99 tons and rated 660 horsepower. No. 905 would be the first of many Alco switch engines that would form the future backbone of the locomotive fleet. (Courtesy of Tacoma Public Library, Richards Studio Collection.)

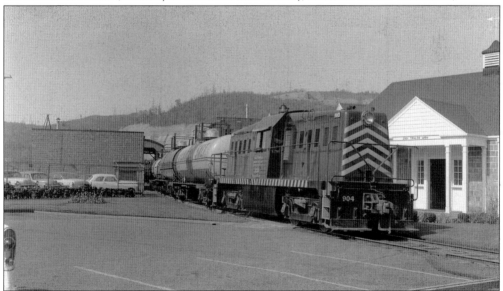

SWITCHING CHEMICALS. No. 904 *Jay McCune* is pushing a string of Penn Salt tank cars into the plant. The siding track went right past the chemical plant's front office. Chemical plants needed rail service on a daily basis. (Courtesy of Tacoma Public Utilities.)

NEIL KIME. Tacoma Municipal Belt Line superintendent Neil Kime served in that role for 13 years, from 1945 to 1958. He was known as an aggressive manager who witnessed the expansion of the Tide Flats and worked to position the Belt Line to better serve the region. He recognized the need for the Belt Line to modernize its locomotive fleet even though cash flow was low. Kime came to the Belt Line from the Tacoma Office of Tax Commission. He was tasked with putting the Belt Line on solid financial footing. Kime also worked on finalizing the Belt Line's first interchange yard. He oversaw the Belt Line debt from trolley days carried over to city light. (Courtesy of Tacoma Public Utilities.)

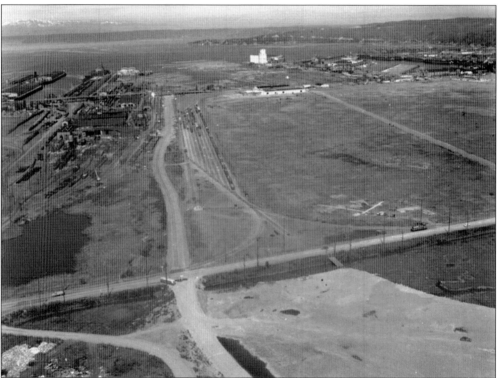

INTERCHANGE YARD. One of the key issues that came out of a chamber of commerce "encouraged" study of the Belt Line's operations by the national rail carriers was the Belt Line's need for a classification yard, where cars could be interchanged with them. Through council approval in 1944 and loans and grants totaling over $280,000, construction was started on 15 acres of land parallel to the Milwaukee car shops on Milwaukee Avenue. The yard was mostly finished by 1945. It was later expanded but soon found itself in need of more capacity than the site could handle. The photograph shows the new yard just left of center of the picture. Note the larger Milwaukee facility on the other side of Milwaukee Avenue. (Courtesy of Tacoma Public Utilities.)

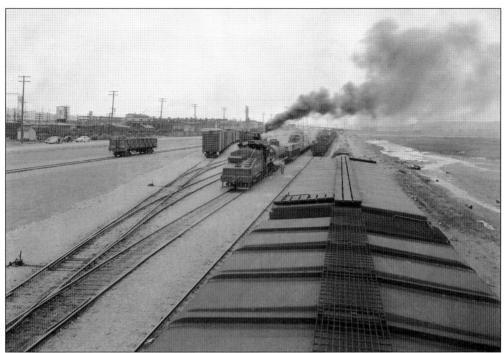

NEW TERMINAL. Municipal Belt Line No. 912 switches in the new classification yard. One of the issues that long plagued the Belt Line since its start was the lack of a classification yard. This was at the top of the list by the national carriers maintaining that the Belt Line lacked a location where the other railroads could drop cars destined for the Tide Flats and pick up outbound cars. The new yard greatly modernized the Belt Line's operation. Note the Milwaukee car shops across the street from the yard. (Courtesy of Tacoma Public Utilities.)

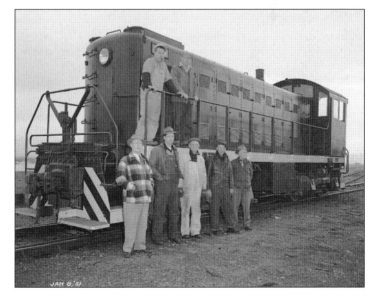

LOCOMOTIVE NO. 905. Even though money was short, superintendent Kime recognized that the Belt Line's locomotive fleet had to be upgraded. Alco S-1 was the first of many Alcos that would come to the Belt Line. The Alco was rated at 660 horsepower. Kime purchased the almost new locomotive for $74,000. (Courtesy of Tacoma Public Utilities.)

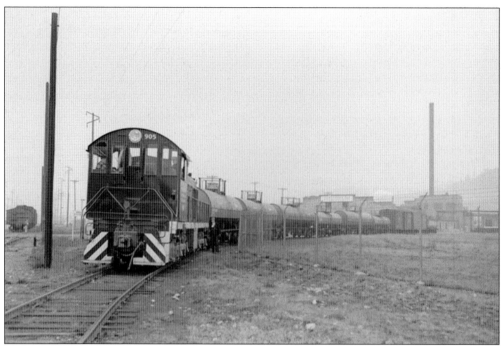

ALCO NO. 905 AT WORK. Alco S-1 is backing cars into the Penn Salt chemical complex on Taylor Way. The No. 905 started as a demo locomotive for Alco. A demonstrator locomotive was a pilot of a future run. It would visit other railroads with sales staff and do actual work for the railroad it was visiting in hopes of generating orders for the factory. Being almost new, the Belt Line paid $74,000 for it. This locomotive was the last major purchase by superintendent Kime. (Courtesy of Tacoma Public Utilities.)

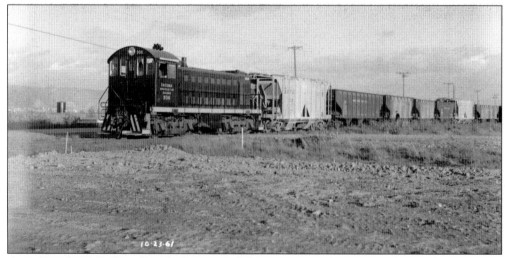

ALCO ERA. In 1962, Carroll Burk, Tacoma Belt line superintendent from 1958 to 1964, purchased Alco S-3 No. 906. Part of the purchase was financed from the sale of one of the Belt Line's General Electric locomotive. No. 906 was the second Alco switcher purchased for the Belt Line. Unlike the Whitcomb locomotives (Nos. 903 and 904), the Alcos proved not only to be up to the job of moving heavy trains in the Tide Flats but also being mechanically reliable and easy to work on. Alco manufactured the No. 906 in 1950. (Courtesy of Tacoma Public Utilities.)

CARROLL BURKS. Carroll Burks was superintendent of Tacoma Municipal Belt Line from 1958 to 1964. He was one of the first superintendents who had railroad experience—he was a railroader by profession and had worked for the Pennsylvania Railroad and served in the Army Transportation Corps, constructing a railroad in Liberia. Burks took on the national railroads in trying to win a rate increase for the Belt Line's switching rates. He won a five-percent increase and fought off attempts to sell off the TMBL. (Courtesy of Tacoma Public Utilities.)

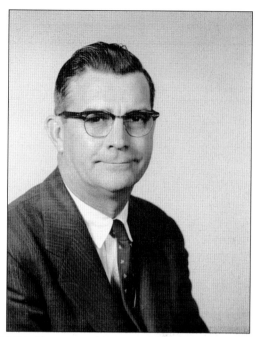

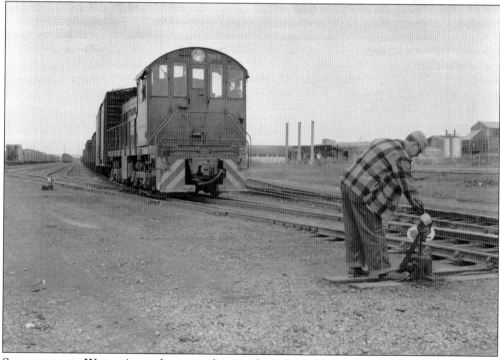

SWITCHMAN AT WORK. A switchman working in the Belt Line's classification yard throws a switch for No. 905 as it sorts cars in the yard. The classification yard and the big Alco switchers were a positive sign that the Belt Line had come of age with trackage and power to handle the needs of the customers. The goal of the Tacoma Municipal Belt Line was not to make a profit but rather to provide a service that would attract businesses to locate in the Tide Flats. The new power and the new yard increased the road's efficiencies. (Courtesy of Tacoma Public Utilities.)

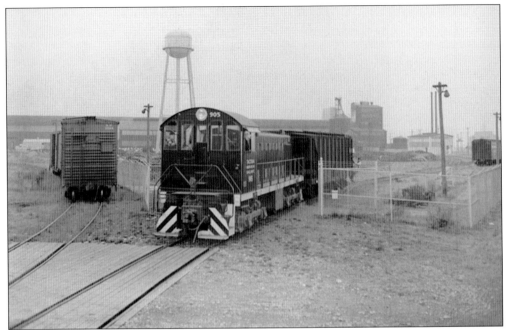

RIGHT CAR, RIGHT PLACE. Tacoma Municipal Belt Line No. 905 extracts a covered hopper from a factory yard in the Tide Flats. The Belt Line earned a motto: "the right car, in the right place, at the right time." The customer satisfaction rate was starting to climb as the Belt Line enjoyed more of the fruits of its modernization. (Courtesy of Tacoma Public Utilities.)

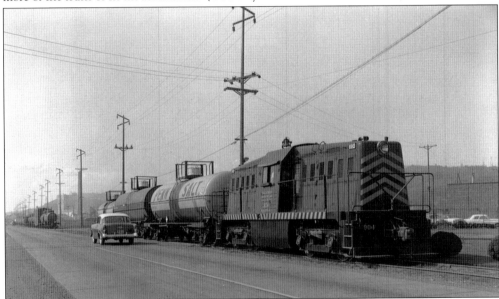

SOLDIERING ON. Whitcomb No. 904 *Jay McCune* soldiers on, pulling a string of tank cars for Penn Salt and leaving other cars behind while it handles the plant's switching chores. The Whitcombs' reliability worsened with age. They had mechanical issues and suffered from cracked frames that needed continual welding repairs. As time went on, they were often sidelined and stored during traffic slowdowns. In 1969, both Nos. 903 and 904 would be removed from the roster and scrapped by General Motors in Tacoma. (Courtesy of Tacoma Public Utilities.)

NEW DAWN. Belt Line staff pose with Alco S-4 921 in the new yard. Tacoma Municipal Belt Line opted for a new paint scheme of gold and maroon. The new yard came about when the Port New Waterway Expansion Project needed the land where the then old classification yard was. (Courtesy of Tacoma Public Utilities.)

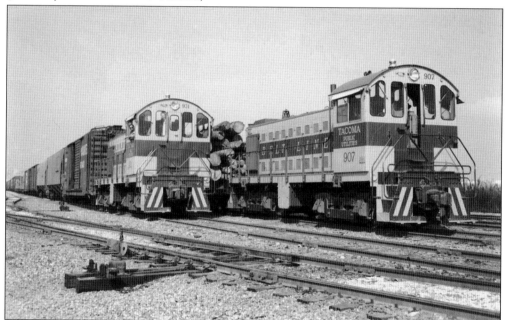

ALCO MOTION. Alco Nos. 931 and 907 (S-4 and S-3, respectively) work side by side in the Belt Line's main yard. Both locomotives bear the new paint scheme. No. 907 is pulling a load of logs into the yard. The Milwaukee and later Chehalis Western would bring log trains down to the Tide Flats with logs to be exported by Weyerhaeuser. This business continued into the 1980s, when changes affecting the logging industry closed many mills and harvesting operations. (Courtesy of Tacoma Public Utilities.)

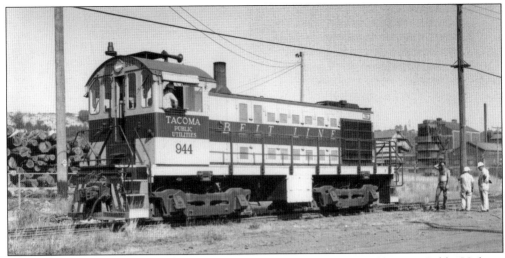

TACOMA PUBLIC UTILITIES. Belt Line No. 944 identifies it as property of Tacoma Public Utilities as it rolls past a track crew. Note the logs at the storage yard by Taylor Way. Logging and lumber were still big commodities, but were slipping in importance, causing management to scramble for other sources of revenue to make up for the shrinking wood products. (Courtesy of Tacoma Public Library.)

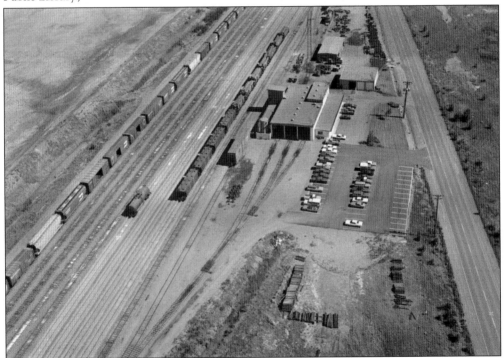

NEW HOME. The Port of Tacoma started a waterway expansion project that centered on developing the area where the Belt Line's classification yard sat. The project started in 1964. The Port of Tacoma reimbursed the Belt Line for its relocation, allowing construction of a new yard, offices, and engine house (see page 68). The yard cost $909,000. The yard could accommodate 440 cars and was later expanded to handle 1,000, which was finished in July 1969. The office and roundhouse were built for an additional $226,000. (Courtesy of Tacoma Public Utilities.)

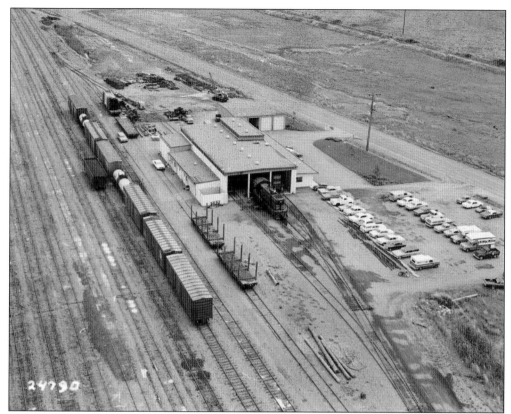

AERIAL VIEW OF NEW ROUNDHOUSE. This roundhouse replaced the $7,000 shed built to replace the Tacoma Municipal Street Railway trolley barn that burned to the ground. The roundhouse and adjoining office complex cost $226,000. An outside storage building is visible to the right. Later, a tower was added on to the office building. This marked the first time that all the operations of the Belt Line were under one roof. Belt Line mechanics could perform all but the heavier repairs in the roundhouse. (Courtesy of Tacoma Public Utilities.)

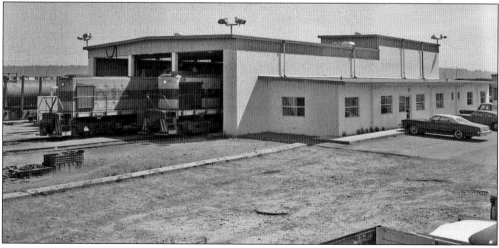

NEW ROUNDHOUSE. A side view shows the roundhouse and some of the offices. The facility opened in July 1969, giving the Belt Line a permanent new home. (Courtesy of Tacoma Public Utilities.)

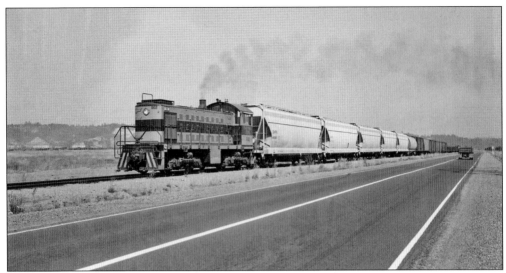

ALCO NO. 902. Here, Alco S-1 No. 902 pulls a long string of freight cars it gathered from the east side of the Tide Flats into the new yard along the East West Road (later North Frontage Road). The No. 902 was constructed in January 1942. It came to the Belt Line in March 1968 from the Portland terminal. The age of this locomotive attests to the durability of the old Alcos that could just keep on running with good maintenance and pull. (Courtesy of Tacoma Public Utilities.)

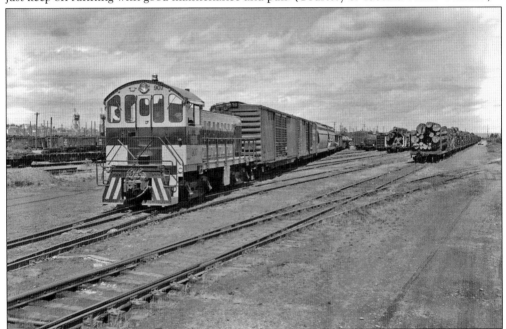

OLD YARD. At one time, the classification yard along Milwaukee Avenue greatly expanded the operations of the Belt Line. By the early 1950s, it was too small and cramped. Here, No. 907 is switching in a very full yard. To the left of the locomotive is the large Milwaukee Road car shop complex. In a few short years, the Milwaukee would pull out of Tacoma. This land and the land the Belt Line's yard are on would become part of the expanding port. This picture was taken in 1969, the same year the new yard opened. No. 907 gave the Belt Line 15 years of service. (Courtesy of Tacoma Public Utilities.)

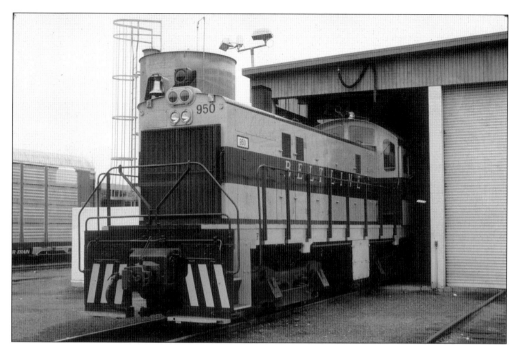

NEW POWER AND NEW HOME. Alco S-6 No. 950 was acquired in 1976. An ex–Southern Pacific locomotive (the Mars Light is a dead giveaway) is poking out of the roundhouse. Note the sanding hose hanging above the cab of the locomotive. The S-6 model was the most modern of the Belt Line's Alco S series switching locomotive. It was built in 1956. (Courtesy of Peter Replinger.)

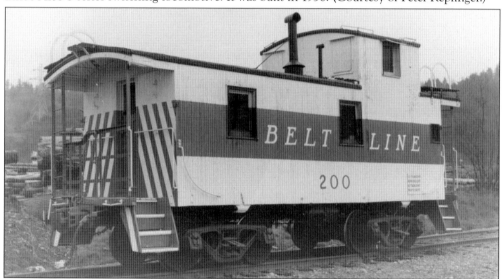

BELT LINE CABOOSE. The Belt Line had one caboose. Its heritage is obviously Northern Pacific. The caboose was used on the line that ran around the end of the Hylebos Waterway. Operationally, this was a backup move operation as there was no room for a turnaround track on the end of this Line. The train would back down the line to its several customers. The caboose would protect the rear of the train. A crewman would ride the back platform of the caboose to guard against traffic on the road crossings and many business drives along the route. When the operation was over, the caboose would be left at the beginning of the line. (Courtesy of Jim Fredrickson.)

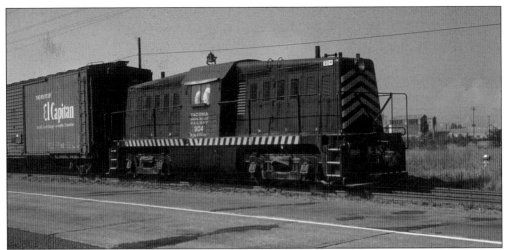

JAY MCCUNE. By the 1960s, Whitcombs No. 904 *Jay McCune* and No. 903 were outclassed. The seven Alco switchers and their nagging mechanical issues worked against the employed World War II veterans. By this time, parts were difficult to obtain for the Budda motors in the Whitcombs. Nos. 903 and 904 tested the Belt Line's mechanics. In a few short years, these same types of problems would plague the Alcos as their builder exited the domestic locomotive market. The two Whitcombs were scrapped in 1969. (Courtesy of Peter Replinger.)

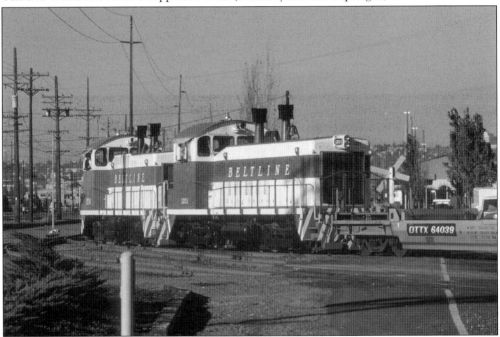

NEW GOLD. The year 1985 marked a historical transition for both the Port of Tacoma and the Belt Line. The Sea-Land shipping line moved from Seattle to Tacoma. This marked a major change within the port from bulk cargo to container cargo. The container revolution was on. Yards were laid out to support the port's effort to capture this traffic. Here, EMD (General Motors) SW-1200 Nos. 1023 and 1204 are pushing empty container cars onto the docks that support the Sea-Land terminal. The increase of container traffic would offset the traditional giant, wood products, which was in decline. (Photograph by author.)

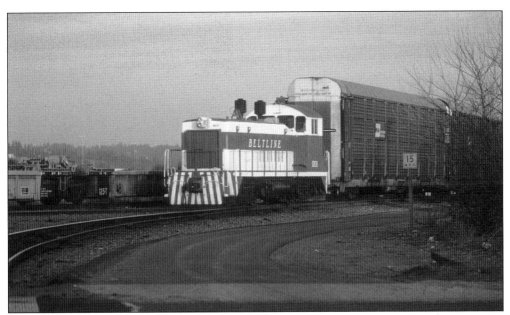

AUTOMOBILE TRAFFIC. No. 1201 brings a string of auto racks into the main yard. Imported automobiles started making an impact in the mid-1970s. Cars were mostly imported from Japan. The port and the Belt Line were in competition with Portland, Oregon, in 1976 to be selected for a distribution point for arriving automobiles. Automobile traffic picked up, and today over nine automobile brands are imported and shipped through Tacoma with a large part of this traffic loading on auto racks on the Belt Line. (Photograph by author.)

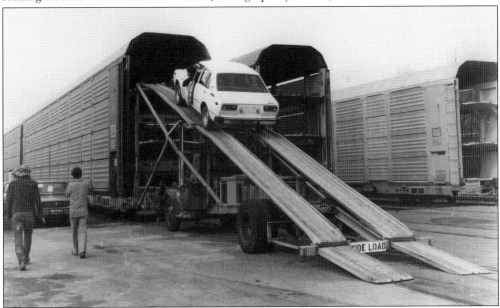

IMPORT INVASION. In February 1976, Toyota Maru unloaded 1,549 Toyotas in the port, as part of a competition with Portland to see which of the two would be a better port to bring its line of automobiles for Midwest distribution. Today, the port has a dedicated railcar facility to handle this traffic. The terminal can handle 72 auto racks and over 1,500 cars at a time. (Courtesy of Tacoma Public Library, Richards Studio Collection.)

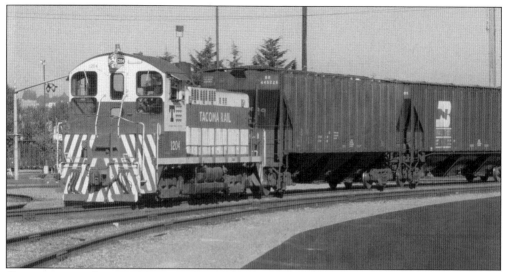

CHANGE OF THE GUARD. Locomotive SW-1200 No. 1204 enters the main yard from the port's bulk docks with a string of covered hoppers. The name Tacoma Rail adorns the engine's flanks. The name change occurred in 1999, for two reasons. Firstly, it was part of a Tacoma Public Utilities image makeover. Public utilities wanted to give its division (water, city light, and Tacoma Rail) a more consumer friendly name. Superintendent Dennis Dean gave the other reason: he said he wanted a name that described what the company did. (Author's collection.)

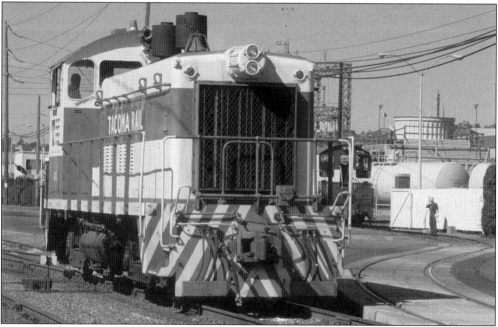

PIONEER CHEMICAL HANDOFF. Pioneer Chemical, found on the site of the former Hooker/Occidental, prepares to receive cars from Tacoma Rail. Note the plant switcher and crewman standing by to receive cars. Chemical plants in the Northwest and Tacoma have taken a hard hit with readjustments of electrical rates. Cheap electricity in the region was one of the attractors for Tacoma's many chemical production plants; with rate increases and a soft demand from the wood products and paper, many plants closed, including the Pioneer plant. (Photograph by author.)

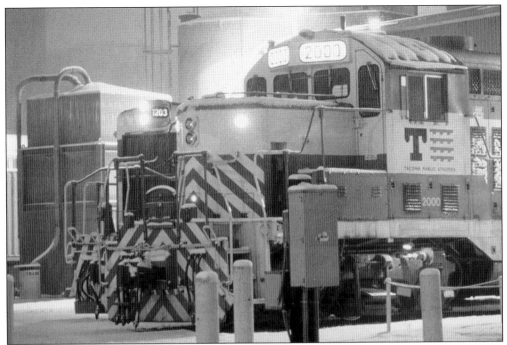

COLD POWER. Two Tacoma Rail locomotives wait a call to service on a cold, snowy morning. EMD No. 1203 SW-1200 was acquired by Tacoma Rail (Belt Line) in 1988. It was built in 1965 for the Missouri Pacific Railroad. No. 2000 is a EMD Model GP-18 (GP stands for general purpose) built in 1952 for the Seaboard Railroad. The Belt Line obtained it in 1992. With the rise in container traffic, there was a need for heavier power. Most of the Alcos are gone, having become victims of limited parts and old age; and Alco had exited the locomotive business, making upkeep more difficult. Tacoma Rail favored EMD products. (Photograph by author.)

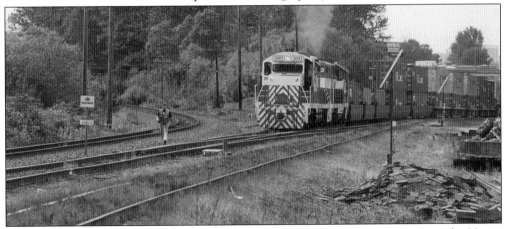

INTERCHANGE. Locomotives Nos. 2003 and 2006 deliver a long container train to the Union Pacific yard in Fife, Washington. The track curving to the left is Union Pacific's main line, crossing the Puyallup River to connect with the Burlington Northern Santa Fe to gain trackage rights to Portland, Oregon, where the Union Pacific will rejoin its own tracks. Interchange traffic is vital business where the connecting railroads hand off cars for the other to deliver or forward. Tacoma Rail has about a third of its traffic go on the Union Pacific while the other two thirds goes on the Burlington Northern Santa Fe. (Photograph by author.)

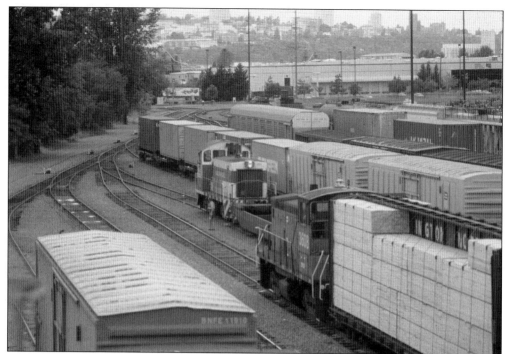

BUSINESS AS USUAL. Burlington Northern's transfer job is exiting Tacoma Rail's main yard. Burlington Northern transfers bring freight cars to Tacoma Rail's central yard daily. The train crosses the Puyallup River at Bullfrog Junction (just east of Tacoma Rail's yard) from its own freight yard, located right across the river. This was the former Northern Pacific yard that superseded Northern Pacific's Half Moon Yard as Northern Pacific's main terminal. The railroads run these transfers to exchange cars for delivery or shipment. (Photograph by author.)

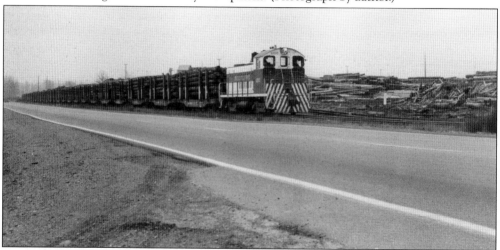

LOG TRAFFIC DOWN. SW-9 No. 1200 pulls a string of log cars. This was for many years the mainstay of Tacoma Municipal Belt Line's freight traffic. As logging patterns changed in the Pacific Northwest, log traffic began a steep decline. In 1983, logs made up 31 percent of Tacoma Rail's hauls. Also at this time, the large United Grain terminal closed its doors due to the parent company concentrating on its Portland, Oregon, location. The silver lining at this time was the growth of container traffic. (Courtesy of Walt Ainsworth collection.)

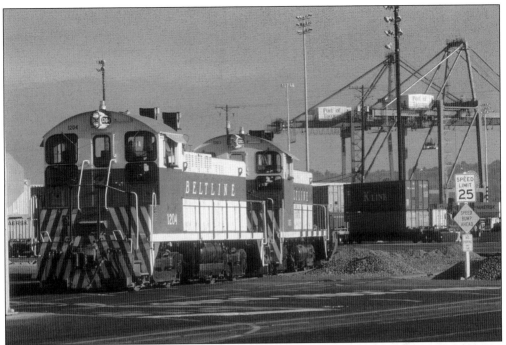

NEW BUSINESS. With the arrival of Sea-Land in 1985, this became a more common sight; Nos. 1203 and 1204 push empty container cars into the port's intermodal terminal. Container traffic would surpass the disappearing log traffic but it would take a few years to fill the gap. (Photograph by author.)

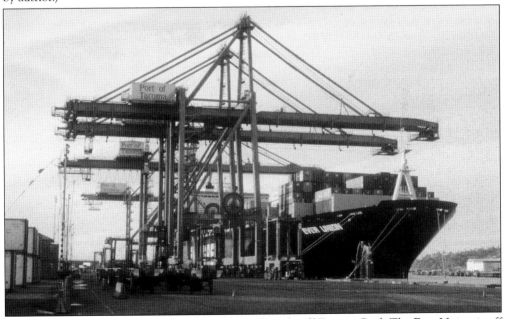

EVER DIAMOND. *Ever Diamond* loads containers directly off Tacoma Rail. The Ever Union is off the Evergreen Line (Taiwan). This area of the port was shared with K Line and Sea-Land and others. Evergreen has since greatly expanded its Tacoma operation and moved to its own terminal south of this location. Tacoma is still where rails meet the sails. (Photograph by author.)

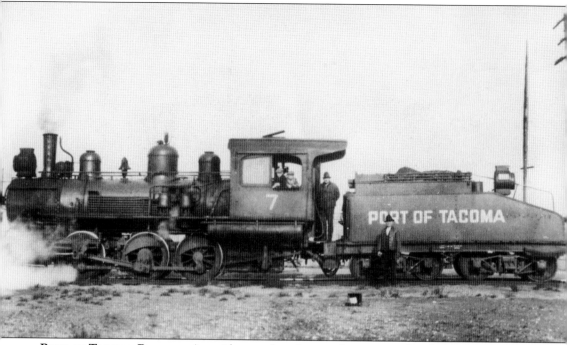

PORT OF TACOMA RAILWAY. An aside must be taken at this point to briefly cover the Port of Tacoma Railway: The Port of Tacoma took seed in 1912 as the Tide Flats was being developed. The push was for a publically owned port to export many of the products in the Tacoma area. The Army Corps of Engineers built levees along the Puyallup River, allowing the port to build and develop piers along the mouth of the Puyallup River. As pier No. 1 was completed, a rail line needed to be built to connect it and future piers to the nearest railroads. Eventually, the J-shaped line connected to the Milwaukee Road, Northern Pacific, and Belt Line. On March 21, 1921, the first train from the Milwaukee Road yard in the Tide Flats ran to pier No. 1 over the port's rail line with 25 loads of timber for Japan. The 0-6-0 No. 7 was the first locomotive purchased for the Port of Tacoma. It was acquired in 1925 and was used until 1944. After that, the Port of Tacoma Railway owned a vast assortment of used locomotives, such as Alco No. 704. (Courtesy of Tacoma Public Library.)

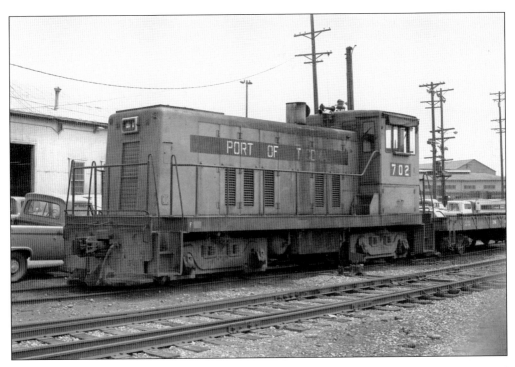

MERGER. The year 1985 marked the year that Tacoma Belt Line would merge with the Port of Tacoma Railroad. The merger had been recommended to streamline operations. Part of the merger deal was a one-year honeymoon to give the port time to decide if its rail customers were happy with the service. (Above, courtesy of Tim Johnson; below, courtesy of Peter Replinger.)

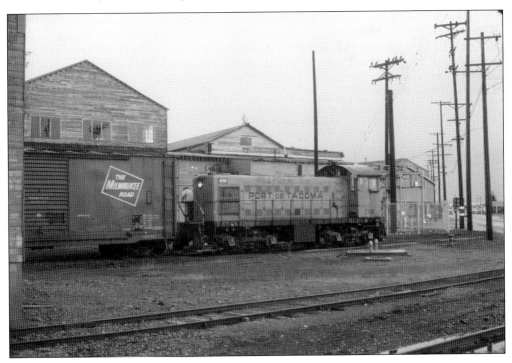

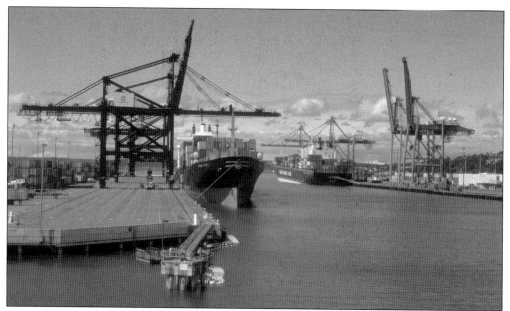

LOADED COMMERCE. The year 1998 finds the port bustling with container traffic. That year, the port generated $21 billion in trade, moving over 12.4 short tons and making the port Tacoma Rail's most important customer. Shipping companies that visit the port or have terminals here include Evergreen, K Line, Maersk, Sea-Land, and Hyundai. The port officially started in 1918 with the opening of pier No. 1, which was used mostly for exporting logs to Asia and to domestic locations. The port has since grown six container terminals and an automobile export terminal. The port not only impacts Tacoma Rail's bottom line but also supports region-wide commerce. Two ships on the Sitcum Waterway in the port are loading containers. Most of these containers have been off-loaded from railcars brought to the terminal by Tacoma Rail. (Photographs by author.)

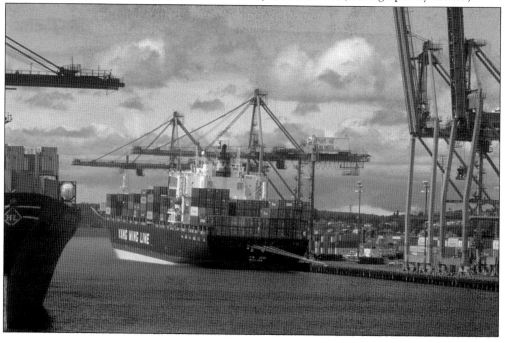

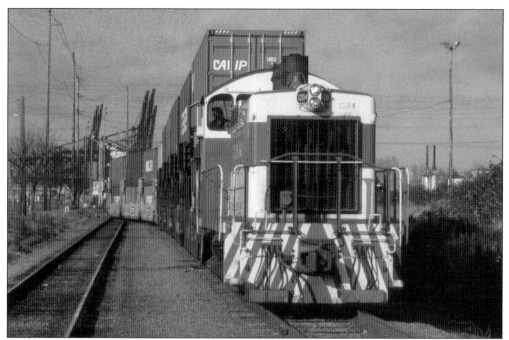

CONTAINERS FOR THE PORT. SW-1200 backs a long string of container cars through the south intermodal yard to be loaded either at the Sea-Land (now APM) terminal or Olympic container terminal. Both terminals sit astride the Sitcum Waterway at the head of Commencement Bay. SW-1200 (ex–Missouri Pacific No. 1191) came to Tacoma Rail in 1999. (Photograph by author.)

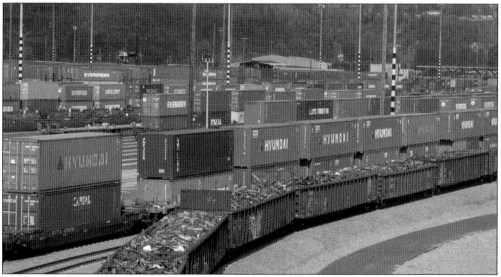

CROSS SECTION. This photograph provides a good cross section of freight handled by Tacoma Rail. The gondolas loaded with scrap metal are destined for Schnitzer Steel for export overseas. The Hyundai containers are destined for the Hyundai intermodal yard (Washington United terminal), located just north of this location. The Evergreen cars are in Evergreen terminal (Pierce County terminal). Both of the container terminals are located on the Blair Waterway in the port. Schnitzer Steel is located on the Hylebos Waterway. Readers can refer to the map on page 53 for the basic layout of the waterways. (Photograph by author.)

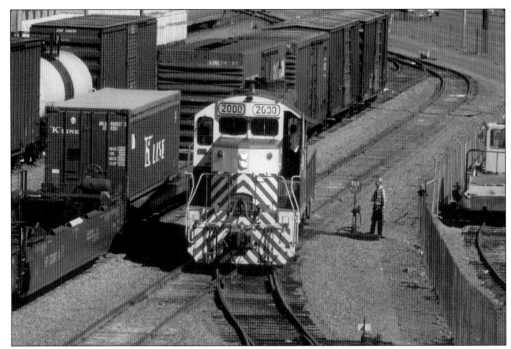

BIGGER POWER. With the need to move longer and heavier trains in the port with the growth of container traffic, Tacoma Rail needed to buy more powerful locomotives on the secondhand market. The answer came in the form of EMD's (General Motors) GP (Geep) series of locomotives. The first two were Nos. 2000 and 2001. Both of these were GP-18 models. They were ex–Seaboard Air Line Railroad locomotives and were built in 1952. The GP-18 produced 1,800 horsepower. Here, No. 2000 is backing out of the roundhouse onto a yard lead to start its shift. Nos. 2005 and 2006 pictured below are rated as GP-20, which produced 2,000 horsepower. Also in the picture, the engines are actually pushing a long string of container cars to the Washington United terminal, located on the other side of the yard. Pushing or pulling long container trains through the curvy track required a lot of horsepower and weight to keep from slipping. The Geeps helped provide that service. (Photographs by author.)

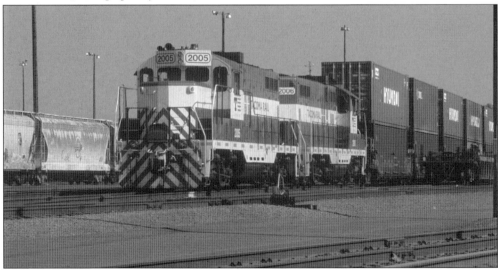

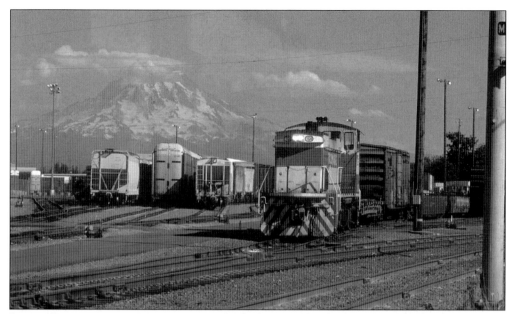

IN THE SHADOW OF THE MOUNTAIN. Working always in the shadow of Mount Rainier, MP-15ac No. 1521 is in Tacoma Rail's main yard. Visible to the far left in the photograph is the automobile export terminal (Marshall Avenue auto facility). One sees a good crosscut of Tacoma Rail's traffic. MP-15ac came to Tacoma Rail from National Railway of Mexico with three sisters. They were built in 1982 and purchased secondhand by Tacoma Rail in 2003, providing the necessary weight and horsepower to work long cuts of cars in Tacoma Rail's yard. (Photograph by author.)

DERAILMENT. A derailment occurred when locomotive No. 1524 was returning in the west end of Tacoma Rail's main yard. Here, the tank car jumped the track but is quickly being rerailed by the track crew. Derailments were common on Tacoma Rail's early days as the railroad lacked the finances to upgrade the old tracks. Carloads and tonnage have continually increased and stressed older tracks. As its finances improved, Tacoma Rail applied aggressive maintenance procedures and upgraded the infrastructure system-wide. (Photograph by author.)

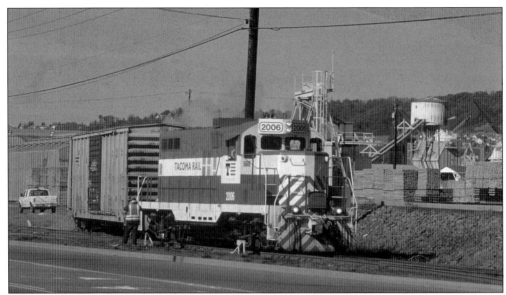

MILL WORK. Locomotive No. 2006 drops a boxcar for loading at a mill on Taylor Way. Much of this traffic has disappeared from the Tide Flats. Once the biggest source of traffic for both the Belt Line and Tacoma Rail, it slowly faded along with logging trends in the Pacific Northwest. The truck to the left of the boxcar belongs to the switchman standing next to the locomotive. The switch operator drives ahead of the train to line up track and open and close gates, saving time for the locomotive crew, which benefits both crew and customer. (Photograph by author.)

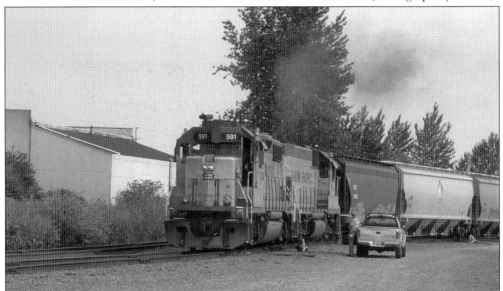

UNION PACIFIC TRANSFER. A Union Pacific Railroad transfer freight approaches the west entrance of Tacoma Rail's main yard with cars from Union Pacific's Fife yard. Daily trains are exchanged in each railroad's yards as cars are picked up and sorted according to their destinations. The person by the pickup truck is Tacoma Rail's yard clerk. His job is to record each car that the visiting railroad brings into the yard and also the cars they take on the return trip. This is a round-the-clock job as transfers come and go. Once the cars are dropped, they are sorted according to their destination along Tacoma Rail. (Photograph by author.)

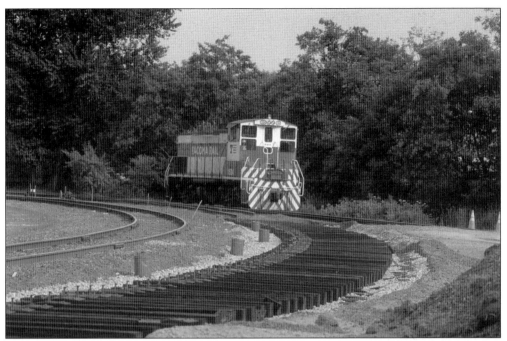

TRACK UPGRADE. Tacoma Rail employs an aggressive track upgrade, replacing worn-out sections of track as quickly as possible. Current superintendent Dale King has made safety a number one priority. No. 1524 passes an area that is ready to get replacement rail on the west end of the yard to increase "receiving" capacity here. Work must be coordinated with yard operations to keep from plugging up the yard. In an orchestrated moment, a main switch is installed at the west throat of the yard. The switch was manufactured off-site so it could be dropped into place, saving downtime for the yard. (Photographs by author.)

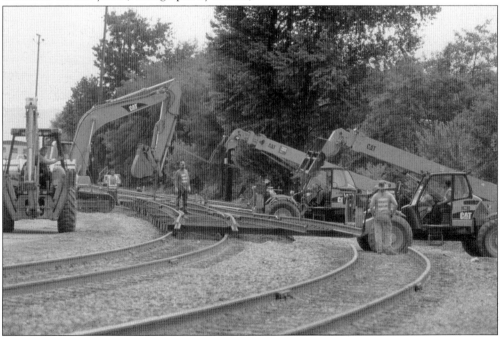

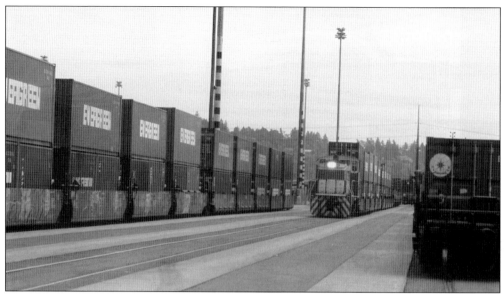

SEA OF CONTAINERS. One of Tacoma Rail's MP-15ac's is switching in the Pierce County terminal for Evergreen. Evergreen invested in a large terminal in Tacoma to take advantage of the deepwater port that would allow the company's larger ships access to an excellent rail and highway outlet. (Photograph by author.)

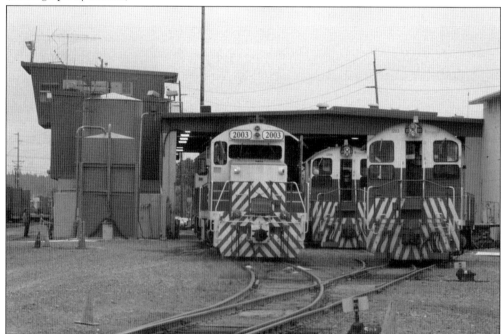

WAITING CALL OF DUTY. Visible here are four of Tacoma Rail's locomotives waiting outside the roundhouse/office building. This terminal has been significantly upgraded since its original construction. Added since then was the tower located on top of the office building, allowing the yardmaster a bird's-eye view of operations in the main yard. Also, sand tanks have been built outside the roundhouse door, allowing better service for locomotive upkeep. The yard is a far cry from the facilities that the Belt Line endured earlier in its history. (Photograph by author.)

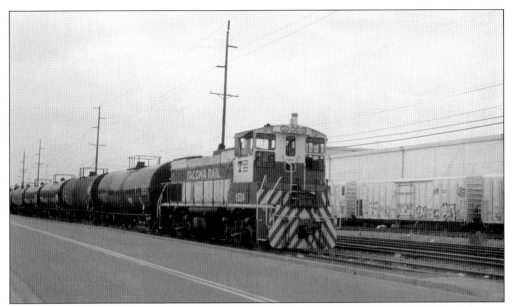

BUSINESS ON TAYLOR WAY. Locomotive No. 1524 rolls down Taylor Way with a string of empty tank cars. In the background are refrigerator cars for use for frozen food products. The Tide Flats area of Tacoma Rail had close to 60 different customers. This number has diminished as traditional commodities changed or went away, and the port took up more land for additional container terminals. (Photograph by author.)

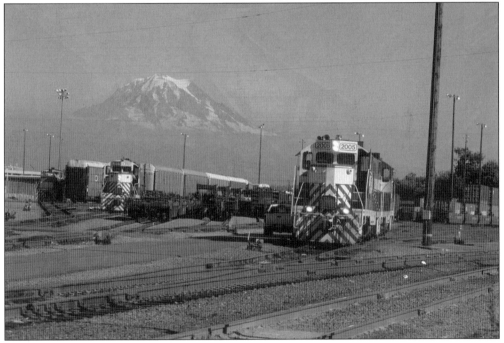

THREE IN ONE. Three different jobs are depicted here at the west end of Tacoma Rail's main yard. Visible are loaded container cars, empty container cars, loads of scrap metal, and auto racks—all a good crosscut of Tacoma Rail's day-to-day operation. A certain amount of orchestration takes place to keep the yard fluid and traffic continually moving. (Photograph by author.)

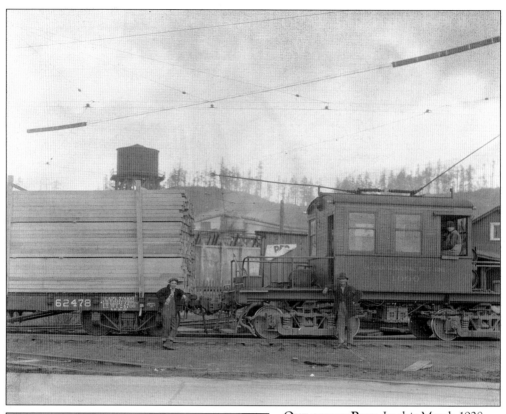

OUT OF THE PAST. In this March 1928 picture is a glimpse of Tacoma Rail's roots as a trolley line to transport workers to and from the Tide Flats; it grew into a modern-day terminal operation that is a vital partner with the port and community of Tacoma, moving commodities around the world. Tacoma Rail helps make Tacoma a world-class player in the global economy. (Courtesy of Tacoma Public Utilities.)

CURRENT SUPERINTENDENT. In 2008, Dale King was appointed superintendent of Tacoma Rail. His railroad heritage includes working for Weyerhaeuser's rail operations and the Burlington Northern and other railroads. (Photograph by author.)

Four

EXPANSION

Tacoma Rail's core has always been the Tidelands Division of Tacoma. In Tacoma Rail's recent history, two more divisions were added to the railroad for differing reasons. This expanded Tacoma Rail from a local terminal road to a regional carrier, serving Tacoma and Pierce and Thurston Counties.

The first expansion took place with the Mountain Division. The Mountain Division consisted of the old Tacoma Eastern Railroad, which laid down its first tracks south of Tacoma in 1887 in order to tap the vast forested areas around Mount Rainier. By 1910, the tracks had reached Morton. At Fredrickson, the line split to Chehalis, Washington. In 1919, Milwaukee Road took control and ran the line up until 1979, when Milwaukee abandoned its Northwest track. Weyerhaeuser purchased the line in 1980 and operated it as the Chehalis Western, moving mainly export logs to the port. This operation stopped in 1992.

In 1995, the City of Tacoma purchased the line. The reasoning was to encourage economic development along the line. The railroad was put under the stewardship of Tacoma Public Works, but Tacoma Rail was to be the operator. Tacoma Rail named it the Mountain Division after the 3.3-percent grade up the Tacoma Gulch. The main portion of the line operationally is between Tacoma Rail's yard and Fredrickson. At Fredrickson, there is a modest-size industrial park served by Tacoma Rail. The line also hosts Mount Rainier Scenic Railway.

The other division is the Capital Division. The Capital Division is made up of three different lines. The Belmore Line runs from East Olympia, where it connects to the Burlington Northern Santa Fe Railway's main line, to Belmore southwest of Olympia, where an industrial park is served. Of note, the track from East Olympia to downtown Olympia is the former Union Pacific Olympia Line. It is still owned by the Union Pacific Railroad. The Burlington Northern leased it when the Burlington Northern's own track to Olympia was abandoned for an Interstate 5 widening project. Burlington Northern leased rights to access its track in downtown Olympia.

The Quadlok Line runs from St. Claire (just south of Nisqually Junction on the Burlington Northern Santa Fe's main line) to Quadlok, located three miles down the line, to serve Pioneer Paper. The Quadlok Line is the beginning of the former Northern Pacific Olympia Line, in which the Belmore Line is the other end. The final line is the Lakeview Line, which runs north from Nisqually Junction to South Tacoma (part of the former Northern Pacific Prairie Line).

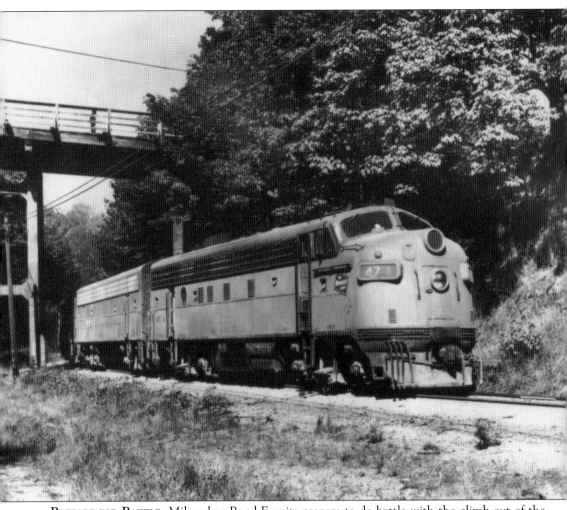

PREPARE FOR BATTLE. Milwaukee Road F units prepare to do battle with the climb out of the Tacoma Gulch. The Tacoma Eastern Railroad originally built this line out of the Tide Flats to tap the rich forest reserves in the Mount Rainier foothills. To accomplish this, the railroad had to climb a steep 3.3-percent grade, known as the Tacoma Gulch. In 1887, tracks were laid up the gulch. This has been an operational challenge that continues today. Milwaukee took control of this line in 1919. (Courtesy of Tacoma Public Library.)

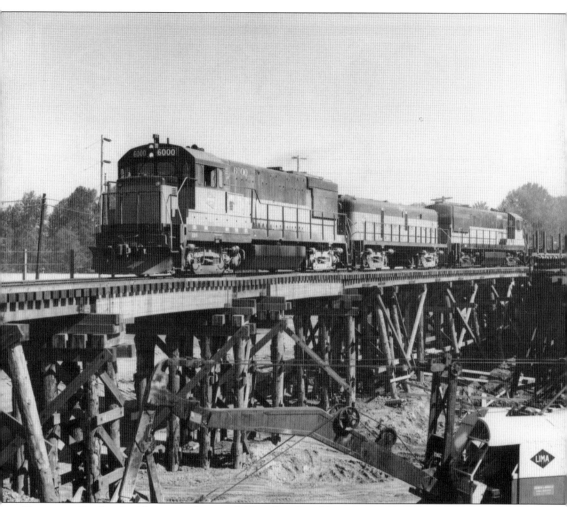

GADGETS. Sandwiched between the two Milwaukee Road locomotives is a slug unit. Slug units were normally retired diesels that had their motors removed; traction motors would then keep the units in place. The unit was then hooked into a parent locomotive, thus allowing the parent unit to have the benefit of the additional traction motors. Milwaukee made several slug units to use on the gulch to assist trains making the climb. The train would often still have to double the hill. This meant the train would be split in half to make two trips up the hill, then be reassembled and go on; this was a very time- and fuel-consuming process. Tacoma Rail often has to follow this procedure. (Courtesy of Tacoma Public Library.)

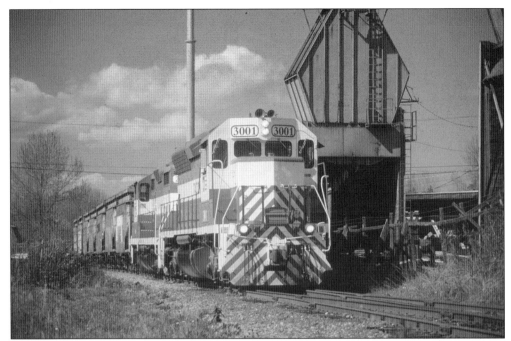

MONSTERS OF THE HILL. When Tacoma Rail started operating the Mountain Division, it was learned that bigger power was needed. This led to the purchase of Nos. 3000 and 3001. Both of these locomotives are rated at 3,000 horsepower, which makes them the most powerful engines employed by Tacoma Rail. No. 3000 was purchased by Tacoma Public Utilities and operated by Tacoma Rail. Here, they are seen with a ballast train and just about to complete an assault on the 3.3-percent grade of the gulch. (Photograph by author.)

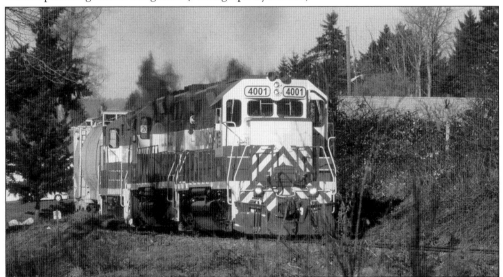

STILL CLIMBING. With 7,100 horsepower, three Tacoma Rail locomotives are in notch 8 on their throttles as they climb Tacoma Gulch. Notch 8 refers to the throttle being opened all the way. It takes a lot of power to lift heavy freight trains from the Tide Flats. Alas, this is only half the train. After leaving their cars on a level siding, the locomotives will drop back down grade and pull the other half of the train up the hill. (Photograph by author.)

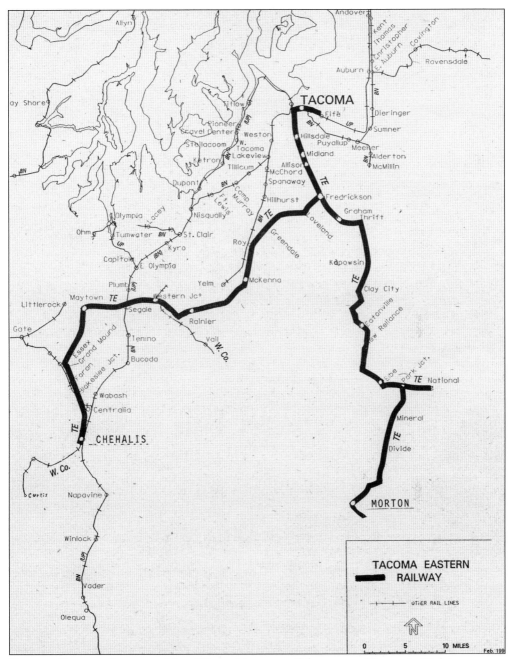

TACOMA EASTERN RAILROAD MAP. Pictured is a map of the current Mountain Division system. (Courtesy of Tacoma Eastern Railroad.)

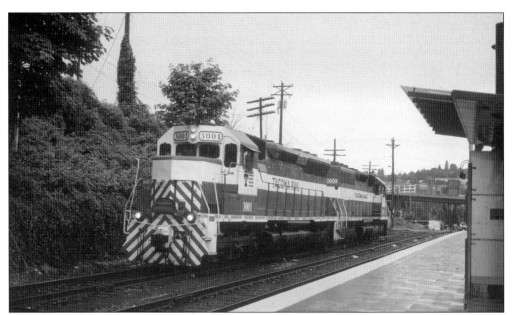

SECOND TRIP. After making the 3.3-percent climb, Nos. 3001 and 3000 have dropped back down to pick up the rest of their train. Nos. 3001 and 3000 represent 6,000 horsepower, which still may not be enough power to lift the whole train up the gulch. The purpose of Tacoma Rail operating the Mountain Division is to encourage economic growth along the line. In the Milwaukee days, many of the former rail customers grew discouraged with Milwaukee's service. Tacoma Rail is working to win them back. (Photograph by author.)

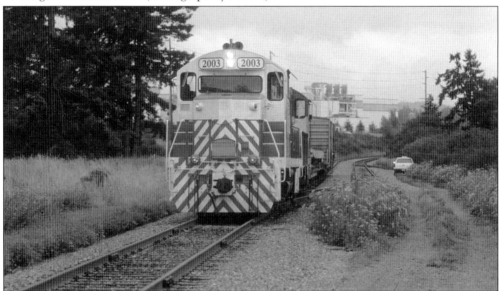

FREDRICKSON. Fredrickson is the bright spot for the Mountain Division. Here, the division splits into two sections. One line goes south to Chehalis, Washington. The other line goes southeast to Morton near Mount Rainier. GP-20 and another locomotive have just arrived at Fredrickson. The locomotives have run around their train and are about to push it back to the Boeing plant in the background. Boeing locating at Fredrickson helped the industrial park to grow. Most Mountain Division traffic ends or originates here. (Photograph by author.)

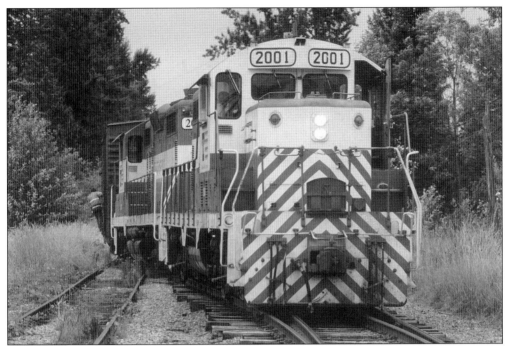

SETOUT. Locomotive No. 2001 sets out cars on a siding on the Mountain Division that it will pick up on its return to Tacoma. This former Milwaukee line has many sidings from the days of running logging operations to and from the port. This required sidings to set out loads for making up trains returning to the port and making up empty trains to hand off to Weyerhaeuser for loading. (Photograph by author.)

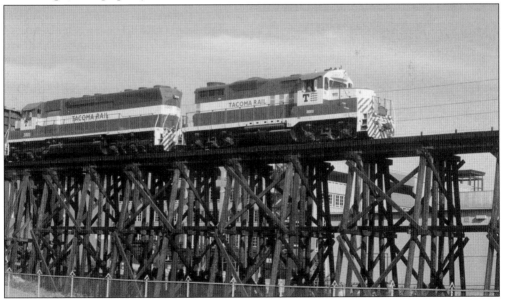

TIPTOE. GP-20 No. 2003 and SD-40 No. 3001 bring a return trip from the Mountain Division across Tacoma Eastern Railroad's landmark trestle bridge in downtown Tacoma. The spindly trestle is still in operation today with not only Tacoma Rail running over it but also the Sounder of Sound Transit. (Photograph by author.)

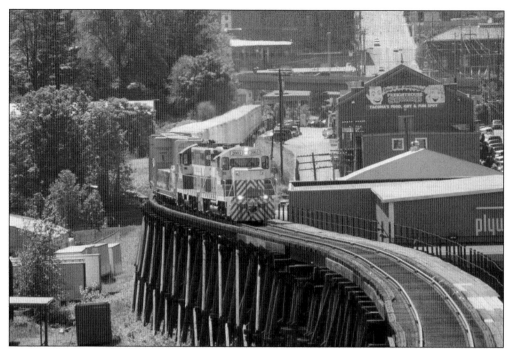

RETURN FROM THE MOUNTAIN. A Tacoma Rail train snakes across the Mountain Division's trestle just past Freight House Square. Freight House Square was the Tacoma Division's headquarters for the Milwaukee Road housing offices and freight storage. Today, it is a retail and restaurant outlet. (Photograph by author.)

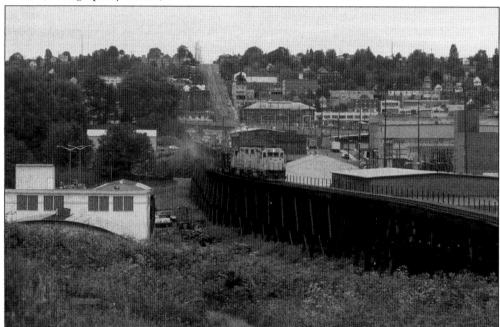

CHEHALIS WESTERN. After Milwaukee quit the West Coast, Weyerhaeuser operated the Chehalis Western to bring logs to the port. Here, the daily log train is arriving in Tacoma. This operation ran from 1980 to 1992. (Photograph by author.)

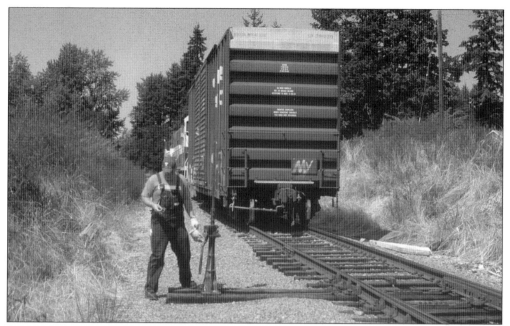

SWITCHING PIONEER. A switch supervisor throws a switch for Pioneer Paper after picking up this car. The Quadlok Line only has one customer, which gets service one or two days a week. (Photograph by author.)

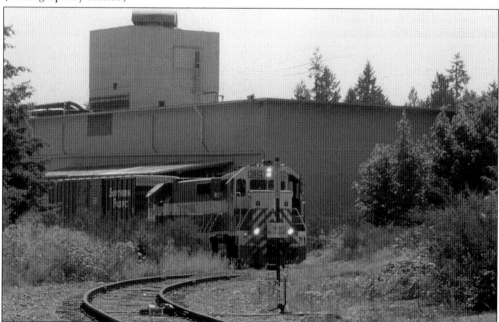

PIONEER PAPER. Tacoma Rail extracts a car out of Pioneer Paper. The Quadlok Line was the former Northern Pacific Olympia Line. The line was abandoned for an Interstate 5 widening project after a leasing deal was worked out with the Union Pacific Railroad for Burlington Northern trains to access Olympia using the Union Pacific rail line. Tacoma Rail operates the line for Burlington Northern Santa Fe today, while Union Pacific retains ownership of the line. (Photograph by author.)

BELMORE LINE. At East Olympia next to the Burlington Northern Santa Fe main line, Tacoma Rail's No. 3801 prepares to pull cars off the interchange track to take to Belmore. The line to the right of No. 3801 is the beginning of the Belmore Line. Union Pacific Railroad owns this line; Burlington Northern Santa Fe leases it but has Tacoma Rail operate it. Crews normally operate two days a week on the Capital Division. (Photograph by author.)

TUNNELS. A first for Tacoma Rail's operation on the Capital Division were tunnels. There are three tunnels on the line between East Olympia and downtown Olympia. Two of the tunnels are on the Union Pacific while the last and largest is located under downtown Olympia. This is former Northern Pacific track. The train has just come off the Union Pacific portion of the line. Shortly, it will cross Capital Lake and climb to Belmore. (Photograph by author.)

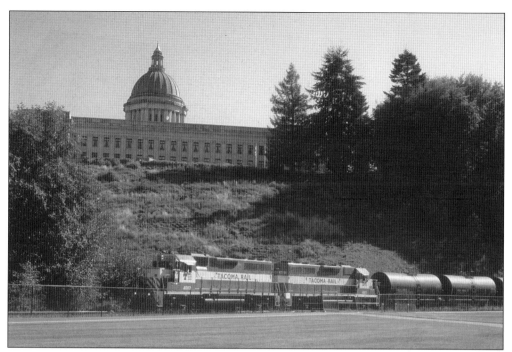

CAPITAL CITY. Running under the shadow of the state capitol dome in Olympia, the Belmore job is on its return trip to East Olympia after picking up outbound cars. (Photograph by author.)

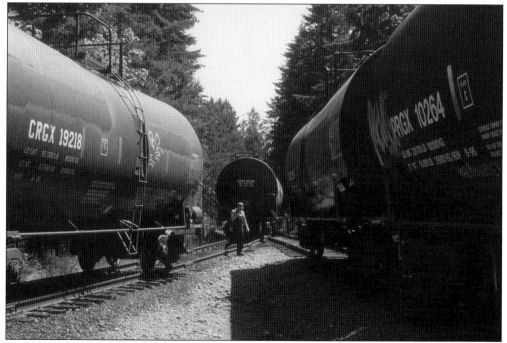

SORTING TANK CARS. Here, tank cars are being sorted in Belmore. Pulling out empty corn syrup tank cars and exchanging them with full cars can often be tricky business. The Belmore Line supports many medium-to-large industries. This former Northern Pacific Railroad line connected to the coast at Hoquiam and Chehalis. (Photograph by author.)

SORTING AT ST. CLAIR. Switch supervisor is throwing a switch to connect the boxcar from Pioneer Paper to the rest of the train. From here, the train will run on the 50-miles-per-hour main line on the Burlington Northern Santa Fe to Nisqually Junction, where it will access the Lakeview Line and tie up for another crew. (Photograph by author.)

BEFORE TACOMA RAIL. Burlington Northern Santa Fe (BNSF) Olympia turns in sight of the capitol dome in Olympia. BNSF offered the operation of its Olympia area lines for lease to short-line operators. Tacoma Rail took over this operation, making it the Belmore Line. Compare this shot with a view of the same location seen on page 107. (Photograph by author.)

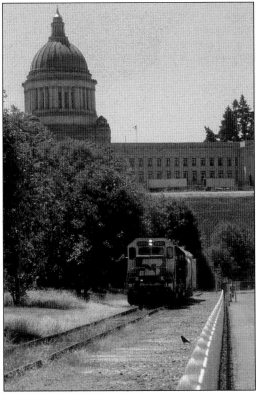

Five

Passenger Excursions

Tacoma Rail nor Tacoma Municipal Belt Line were considered passenger carriers after the retirement of the trolleys in the late 1920s. On an annual basis, Tacoma Rail did run short passenger excursions in conjunction with the Port of Tacoma's open house.

When Tacoma Rail started running the Mountain Division, this changed. Since the Tacoma Eastern Railroad's inception, passenger trains have been running up the steep 3.3-percent grade, carrying passengers to see the wonder of Mount Rainier and its surrounding area. Tacoma Eastern started carrying passengers in 1905. The railroad was the only practical way to see Mount Rainier National Park, dedicated in 1899. The train would go as far as Ashford and then passengers would take alternate transportation into the park. Milwaukee Road instituted the National Park Limited, which ran from Seattle to Ashford. The normal schedule was a 7:30 a.m. departure from Seattle with arrival at Ashford at 10:45 a.m. This train was dropped in 1932.

On Father's Day 2004, Tacoma Rail ran a passenger special to Wolf Haven in Thurston County. Tacoma Rail's track bordered the park, which let passengers off the train to enjoy the park for the day and return in the late afternoon. Between 2008 and 2009, similar excursions were run to Northwest Trek Wild Animal Park in conjunction with Tacoma Metro Parks. Golden Pacific ran 16 trains up the Tacoma Gulch using ex–Reading Northern No. 2100 as the main power. This operation also failed to build up enough to pay for itself.

In 2007, two major players surfaced that looked like a promising fit for Tacoma Rail's Mountain Division. The first was the Washington Dinner Train. The dinner train had been a successful operation in Renton, Washington. The line was slated to be closed, and so the dinner train needed a new home. A 10-month trial was signed between the dinner train and Tacoma Rail from August 3, 2007, up until May 2008. The train ran from Freight House Square to Kapowsin. The operation was stopped after almost three months into the trial. Reasons cited were the extra cost incurred by the route (the climb up the gulch) and soft ticket sales.

The next player was the Grand Luxe Cruise Train. This was a luxury train of 20 refurbished cars. The train operated in two directions, from Mount Rainier to Grand Teton, Yellowstone, and Glacier and also the other direction back. Fares were $4,700–$6,750 per ticket. Grand Luxe leashed three Amtrak passenger locomotives to pull its train, with Tacoma Rail pilot crews onboard. After 15 runs between 2008 and 2009, the company failed, and operations ceased.

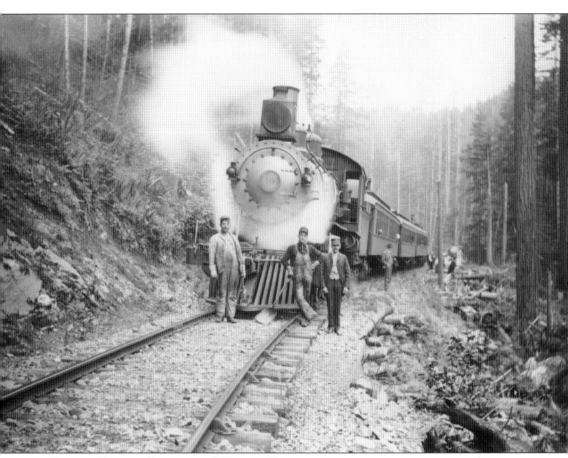

TACOMA EASTERN RAILROAD. A Tacoma Eastern crew pauses a passenger train for a portrait near Mineral, Washington, in this 1908 photograph. Mount Rainier National Park proved to be a popular destination with locals as well as out of the area visitors. In 1913, some 120,000 passengers rode to visit Mount Rainier. The Milwaukee Road took over this operation and ran passengers to the park up until 1932. (Courtesy of Tacoma Public Library.)

SCOUTING RAILROAD MERIT BADGE. Boy Scouts were invited to Tacoma Rail on a Saturday morning to tour the facilities and see firsthand Tacoma Rail's operation. These Scouts are working on their Railroad Merit Badge. Here, they tour No. 2001 at the roundhouse. (Photograph by author.)

LOCOMOTIVE EXPLAINED. Former Tacoma Rail superintendent Dennis Dean explains the workings of a diesel locomotive to Scouts working on their Railroad Merit Badges. The tour included a ride onboard a locomotive so that Scouts could get a firsthand feel for railroading. (Photograph by author.)

TRACK WORK. Boy Scouts learn basic track work under careful supervision of Tacoma Rail staff while touring Tacoma Rail's facility. A Scout here uses a prybar to remove a rail spike from a tie. Another Scout will then pound it back into place. This was a hands-on tour. (Photograph by author.)

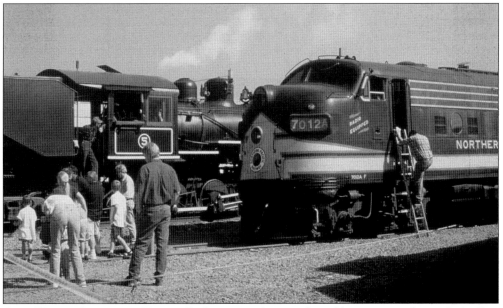

OPEN HOUSE. Once a year, Tacoma Rail opens its doors to the public in partnership with the Port of Tacoma. Here, locomotives from Mount Rainier Scenic Railroad are on hand for the public to see close up. The steam locomotive was employed in moving a passenger train around the port so visitors could see the busy port and rail operation up close. (Photograph by author.)

DISEMBARKING. Here, passengers disembark from a Mount Rainier Scenic Railroad Train employed by Tacoma Rail during its open house. The open house is in conjunction with the Port of Tacoma's open house, where port operations can be seen up close. Selected ships in the port are also on display along with the railroad. (Photograph by author.)

OPEN SHOP. Tacoma Rail's roundhouse is opened up for view to the public during the open house. Here, some people tour locomotive No. 2003 while others look over the locomotive parts or the model train layout in the background. (Photograph by author.)

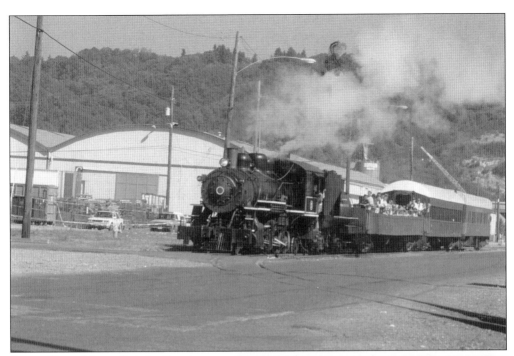

STEAM RIDE. Mount Rainier Scenic Railroad No. 5 powers a tour train through the port during Tacoma Rail and Port of Tacoma's open house. Note the open coach is full, indicating a warm, enjoyable day for those touring. (Photograph by author.)

WAITING IN LINE. Visitors stand in line waiting for their turns to tour GP-20 No. 2003 during Tacoma Rail's open house. Young and old alike enjoy the chance to climb on board a real locomotive. (Photograph by author.)

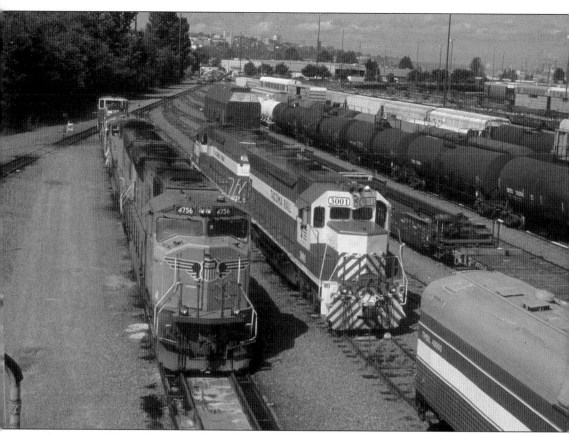

CONTRACT WORK. Tacoma Rail has a working contract with Union Pacific to service Union Pacific's road power as it comes through Tacoma on intermodal trains. This saves Union Pacific a 72-mile round-trip to its nearest servicing facility and the cost of building one in Tacoma. Nos. 3000 and 3001 Mountain Division power are parked next to the Union Pacific power. Power is turned around in less than 24 hours. (Photograph by author.)

WASHINGTON DINNER TRAIN. The Spirit of Washington dinner train conquers the Tacoma Gulch (with the help of a pusher locomotive on the rear end) on a run to Kapowsin on a midday Sunday run. The dinner train started operations on Tacoma Rail's Mountain Division in August 2007. The dinner train had been moved from its Renton location. (Photograph by author.)

PRERUN PREP. Between runs of the dinner train, there were preparations that must be completed to ready the train for another run on the Mountain Division. Here, train staff load groceries and wares necessary to feed hundreds of passengers that make each trip. Also, mechanical and cleaning took place all out in the open, as the dinner train lacked a shop facility to work in. The dinner train was received with much fanfare in hopes of attracting tourists and travelers to Tacoma. Note the generator and floodlights ensuring that much of this work was done after dark also. (Photograph by author.)

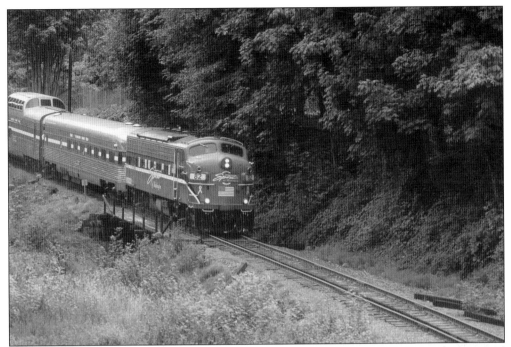

DESCENDING DINNER TRAIN. Dropping back down the gulch, locomotive No. 82, which pushed the train up the hill on its outbound trip, now leads the train down the grade back to Freight House Square, where passengers will disembark after a three-hour combination meal and trip. This spot is the beginning of Tacoma Gulch's 3.3-percent grade. This hill often required an extra locomotive and sometime doubling the hill to get to the top. The dinner train was also required to have an extra locomotive and crew for this run versus the Renton run. (Photograph by author.)

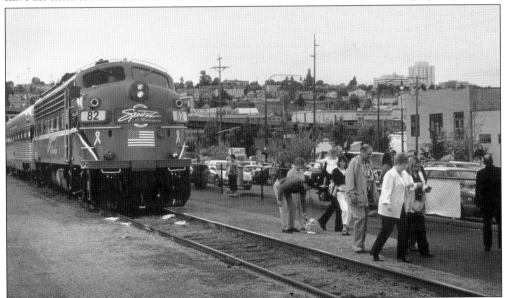

SATISFIED CUSTOMERS. Passengers disembark after their three-hour meal to Lake Kapowsin and back on Tacoma Rail's Mountain Division aboard The Spirit of Washington. Supporters hoped the dinner train would bring more people to Tacoma to enjoy its sights. (Photograph by author.)

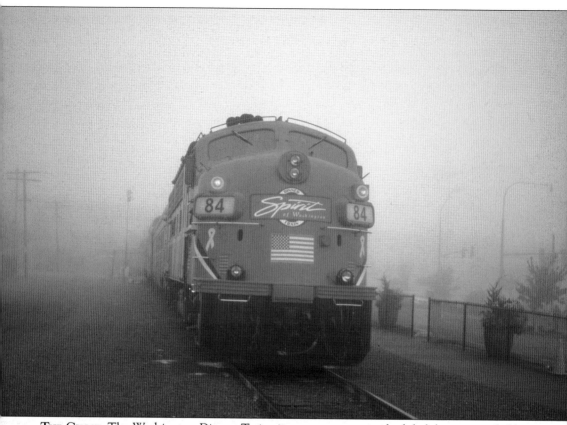

THE GHOST. The Washington Dinner Train sits empty on an unscheduled day surrounded by a misty fog, much like its future in Tacoma. What started with much promise and local support ended as quickly as it had started. The Washington Dinner Train was not quite into its third month of a 10-month trial when the plug was pulled on the run. Management maintained that it had incurred extra operational costs and had softer ticket sales that would not support the train. Rather than continue to run at a loss, the dinner train quit Tacoma early. Had the dinner train been profitable after the 10-month trial, a 20-year contract would have been signed, ensuring that the dinner train would become a long-term fixture in Tacoma. (Photograph by author.)

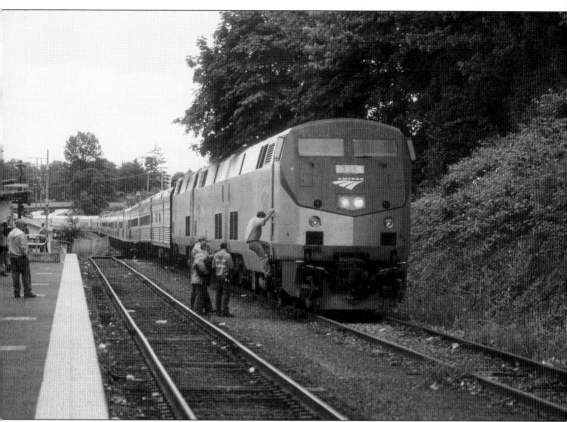

THE GRAND LUXE. A Tacoma Rail pilot crew climbs aboard the Grand Luxe for its first trip on the Mountain Division. The Grand Luxe started operations on the Mountain Division in August 2007. The Grand Luxe was a cruise train that had several runs in the West. The run that came to Tacoma was the Great Northwest Excursion. The train's starting location would be places like the Grand Tetons, Yellowstone, and Glacier National Parks, and its ending location would be Mount Rainier. In Tacoma, the train would run on the Mount Division to Eatonville, where passengers could choose to go to Mount Rainier National Park or Northwest Trek and other attractions. Tickets for the Grand Luxe ran between $4,700–$6,750 per ticket. Locomotives were leased from Amtrak, and cars were Grand Luxe–owned and fully refurbished. (Photograph by author.)

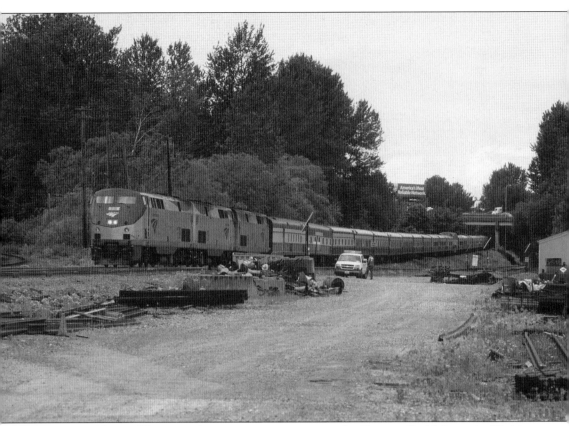

ELEGANT TRAIN. The most elegant train ever to grace the Tacoma Rail Mountain Division, the Grand Luxe is just coming off the Mountain Division in the Union Pacific yard in Fife, Washington. Once the train clears the junction, it will back along the track behind the switch operator's truck to Bullfrog Junction, where it will cross the Puyallup River again and access the Burlington Northern Santa Fe's main line for its trip back east. Never in the history of the tracks of the Mountain Division had a longer passenger train been in regular operation. (Photograph by author.)

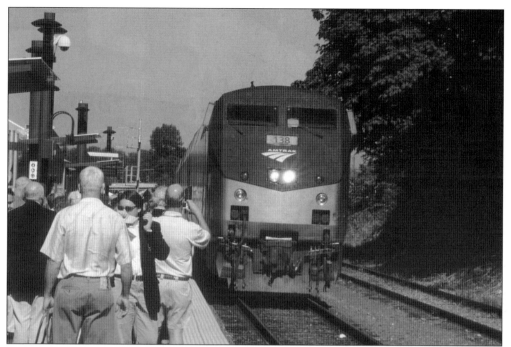

ARRIVAL TIME FREIGHT HOUSE SQUARE. Grand Luxe is seen arriving at Freight House Square to pick up passengers beginning their cruise. Here, passengers meet Grand Luxe agents for boarding. The train would then go onto Eatonville, where passengers could depart to venues of their choice, including Mount Rainier National Park, Northwest Trek, Pioneer Farm, and Eatonville. (Photograph by author.)

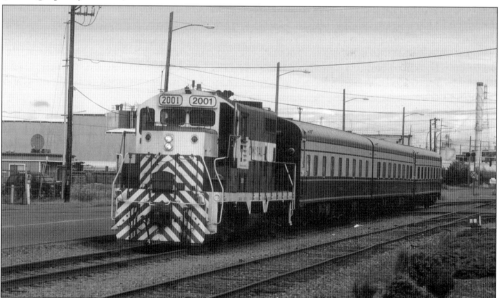

END OF THE LINE. The Grand Luxe was losing too much money to sustain its operation and soon failed. In all, the Grand Luxe made 15 runs on the Mountain Division between 2007–2008, thus ending another dream and hope for passenger operations on Tacoma Rail's Mountain Division. Here, cars are being returned after having some wheelwork done. (Photograph by author.)

TRAIN TO TREK. Train to Trek was a joint venture with Tacoma Metro Parks to run a train on key weekends from Freight House Square to Eatonville, where passengers would be bused to Metro's Northwest Trek Wild Animal Park. The trip offered passengers a comfortable, stress-free ride on Tacoma Rail's Mountain Division, then several hours at the park, and a return in the early evening. (Photograph by author.)

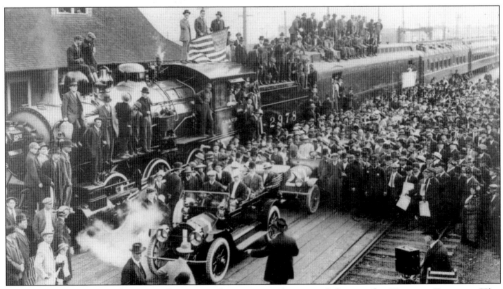

GREAT RACE. Pictured is a race between the train and automobiles on the Tacoma Eastern. The race was on April 27, 1915, between Tacoma and Ashford. The train arrived five minutes before the first automobile. (Courtesy of Tacoma Public Library.)

LAST TREK TRAIN. The last Tacoma Rail Trek train digs in and starts to climb the 3.3-percent grade of Tacoma Gulch. The Trek trains made nine runs between 2008 and 2009, but the last few trains did not fill up. In order to cover costs, the trains need to pretty much be full. It was a good idea with a sad ending. With so many close destinations along the Mountain Division, it is surprising the train-to-mountain concept cannot seem to catch on. (Photograph by author.)

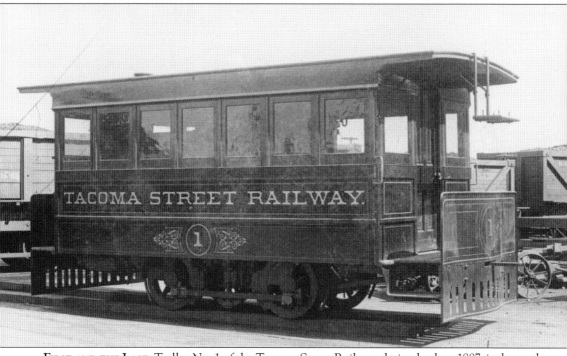

FIRST AND THE LAST. Trolley No. 1 of the Tacoma Street Railway, dating back to 1887, is the seed of Tacoma Rail. What started out as a trolley line would later become a switching terminal road that would provide dependable transportation to and from Tacoma's docks and industry. Tacoma Rail has come a long way to meet the needs of a growing community and region. (Courtesy of Tacoma Public Library.)

TRAIN TO THE MOUNTAIN. A Mount Rainier Scenic Railroad excursion train nears the top of the grade on Tacoma Rail's Mountain Division in a scene similar to the early days of Tacoma Eastern operations. Tacoma has had a long romance with making the city a mecca where passengers can board a passenger train that will take them to the many sights at Mount Rainier. Many feel that this would be a worthwhile attraction that would help tourism and economic development in Tacoma over the long haul. Tacoma Rail could do the job should the right partners come forward and accept the challenge. There are other national parks that have successfully partnered with rail carriers to offer the public an alternative to the automobile when traveling to enjoy parks and other destinations. (Photograph by author.)

Discover Thousands of Local History Books
Featuring Millions of Vintage Images

Arcadia Publishing, the leading local history publisher in the United States, is committed to making history accessible and meaningful through publishing books that celebrate and preserve the heritage of America's people and places.

Find more books like this at
www.arcadiapublishing.com

Search for your hometown history, your old stomping grounds, and even your favorite sports team.

Consistent with our mission to preserve history on a local level, this book was printed in South Carolina on American-made paper and manufactured entirely in the United States. Products carrying the accredited Forest Stewardship Council (FSC) label are printed on 100 percent FSC-certified paper.